Smithsonian Institution Press City of Washington 1975

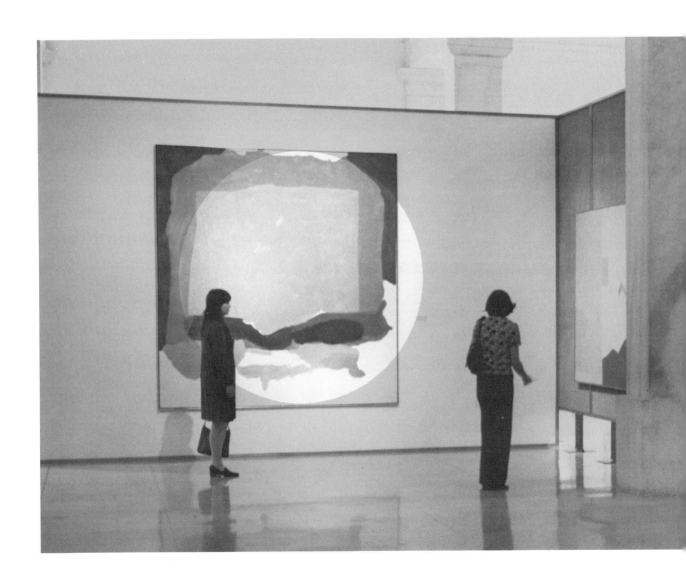

To See Is To Think: Looking at American Art

Joshua C. Taylor

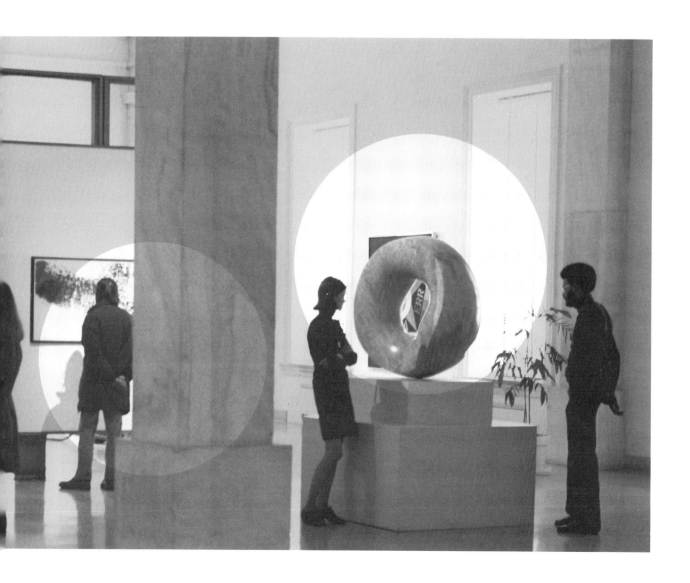

First edition, 1975
Second printing, 1980
Designed by Elizabeth Sur
Printed in the United States of America by Eastern Press, Inc.

Library of Congress Cataloging in Publication Data
Taylor, Joshua Charles, 1917–
To see is to think.
"The brief discussions are based for the most part on
works to be seen in the galleries of the National Col-
lection of Fine Arts in Washington, D.C."
1. Art, American. 2. Art—Psychology. I. Smith-
sonian Institution. National Collection of Fine Arts.
II. Title.
N6505.T38 709′.73 74-26647
ISBN 0-87474-176-9
ISBN 0-87474-177-9 pbk.

Frontispiece: In the Lincoln Gallery at the Smithsonian Institution's
National Collection of Fine Arts

Contents

5

Preface

To look at a work of art is to think. Some people might not call it that—we often limit the word *thinking* to a somewhat pragmatic exercise by which we rationalize various desires, feelings, and other uncalled-for promptings of the brain—but in any case, looking at a work of art is a distinctive use of the mind. Every sculpture, painting, or graphic work provides us with a new mental activity which might very well have the power to engage all our functions from memory to muscular action, from seeing to touch. To be sure, such engagement requires a commitment on the part of the viewer; one has to be disposed to act, but it is only from such a thoughtful, personal encounter that the experience of art has meaning and sensible judgments can be made.

A museum that displays works from the past as well as from the present is not a graveyard of remembered feelings but a source for new experience, a means by which each visitor can expand his own private environment and savor those qualities of perception and thought he might otherwise have missed. To walk through galleries or even to thumb through the illustrated pages of a book on art is to meet with a series of distinct happenings, each one of which marks the fresh union of the eye and the mind. Unfortunately for the hasty viewer, the more one comes to realize that each work of art creates its own special world of thought and sense and makes specific demands on the consciousness, the harder it is simply to walk through a gallery of art or look idly at reproductions. Looking at a work of art takes time; only in time can the work reveal itself to the mind. But then, a personally garnered repertory of thoughtful experiences is worth many times a simple inventory of remembered artifacts.

That a kind of social prestige is often associated with pronouncements on art may be hard to account for, but cannot be overlooked. Ignorance of a scientific fact can be publicly admitted without a feeling of disgrace, but the defiant cry of "I

know what I like" seems socially necessary when it comes to art; not only to admit, but to defend ignorance. There is a difference in the two kinds of ignorance, to be sure. The factual information that will satisfy some question about a scientific matter is quite unlike the response needed to answer most queries prompted by a work of art. There is, admittedly, a great mass of information that can be furnished about art and artists, and a specialized language has been developed by critics and art historians filled with "movements," "-isms," and "stylistic influences" that well might intimidate anyone who has not been initiated by taking the proper courses or reading the required books. Faced with the strange tongue used in art-historian country, a self-conscious viewer of art might hesitate even to frame a question. Defiantly proclaimed ignorance is perhaps the only way he knows to protect his private experience. But everyone must question—questioning is the irresistible impulse of a living mind. In encountering a work of art, however, the first question should not be about how the work can be described in someone else's language or be fitted into a preexisting order, but about how differently the mind works because of the encounter. The viewer should first question himself, not the expert. Sometimes specific historical information about the original content of the work is necessary in order to penetrate beyond the limits of our own perception, but schemes and external situations, fascinating as they are, can never substitute for the direct intercourse between the viewer and the work of art. It is with that relationship these essays are concerned.

The brief discussions are based for the most part on works to be seen in the galleries of the National Collection of Fine Arts in Washington, D.C. Although they span some two centuries and are all by American artists, they have not been chosen to represent in any comprehensive way the history of American art. They have been used simply to raise some questions that might be revealing in looking at individual works from that complex tradition, and to provide the occasion for discussing some ways in which the eye and the mind have worked together in formulating and clarifying ideas about ourselves and our environment

throughout the history of our art. Nor are the problems raised exclusively those of the American tradition. Although art may draw on the local environment, the concerns of which it treats admit of no national boundaries. The eye related to the mind through art has been a pleasure of all peoples and all times.

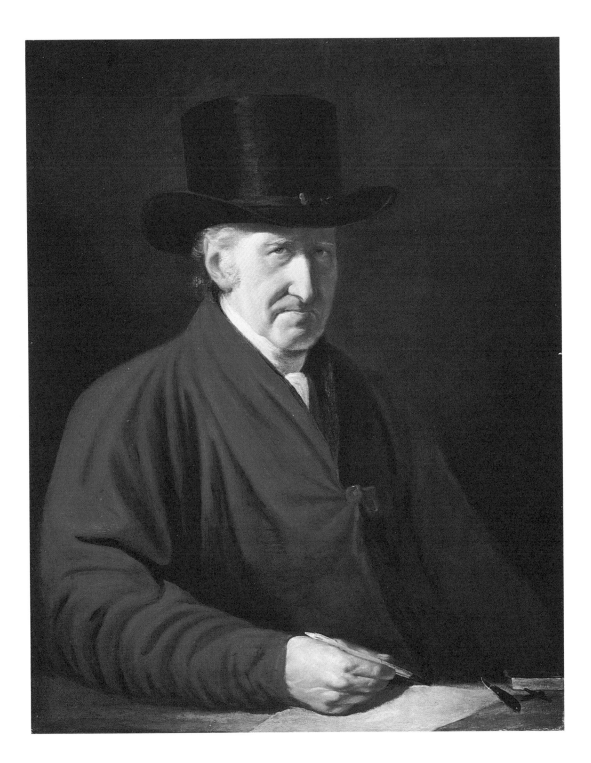

How Do You Know It's a Portrait?

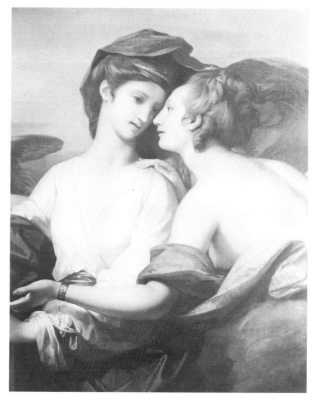

It is astonishing how sure people can be in declaring that a portrait is or is not like the sitter when they have never seen the person. Qualities seem to be built into the portrait which convince us that it records the likeness of someone we could know, a particular person we would recognize again. But the question might also be turned around: how do we know when we come upon the representation of a human face in a painting or sculpture that it is not a portrait? If it is not a portrait, what is it?

There is no question that the sly-faced old man depicted by Benjamin West is an individual; in fact, it is a portrait of West himself [1]. Painted with candor and a kind of detachment, it suggests that the elderly artist was content to observe even himself with a sharp, analytical eye. What then of the painting of two young women [2], a detail from an earlier work by West? They seem to live in quite a different world. Is the difference simply of age? Sex? Or are these latter really portraits?

Quite probably one reaction might be that the young ladies are too perfect to be real, but such an observation gets us nowhere unless we wish to define what we mean by perfection. They do not, in fact, exactly meet present popular standards of perfect beauty. Quite possibly they seem "too perfect," because their characters are so impenetrable. There is no clue as to how they might act or move outside the present situation. Yet there is a kind of motion in their depiction [3]. Every contour and line, in fact, seems subtly to move from fixed point to point, echoing in its rhythm some aspect of every other line. And the rhythm itself is interesting. No line is quite straight nor is any curve simply the arc of a circle. Their slight, subtle variations make a particular demand on the attention, emphasizing the fact that

[1] facing: Benjamin West. *Self Portrait.* 1819.

[2] above: Detail from Benjamin West's *Helen Brought to Paris.* 1776.

the nicety of their relationships is not a matter of chance. The more one looks at the central figure, it seems, the more one finds of remarkable coincidence. The lower lid of the eye exactly parallels the line of the jaw, while the upper lid forms a delicately adjusted parenthesis with the line of the chin. The ear obediently picks up the jawline, which terminates usefully at the angular fold of the rhythmical drape that covers the head. The ear is also harmonized with the curl of hair in front and the silhouette of drapery below. Everything, in fact, seems to be in tune, moving with a carefully proportioned rhythm that unites feature to feature, and each part to the whole.

It is not that West's self-portrait lacks unity nor that the contours are wanting in rhythm. Every line has a purposeful movement, and a flood of light reveals the figure as a solid whole. There is something contrary, however, about the lines of the face [4]; they seem to push in opposite directions and are continuously interrupted by the suggestion of bulging flesh. There are distinct parallels amongst the lines, but their relationship is one of tension because of the disruptive, intervening rhythms. Nor are the rhythms of the face the same as those of the hand and drapery. Each form has its own kind of character. The source of the rhythms would seem to lie within the figure, not outside, giving the liveliness that is at once apparent an aspect of self-determination, suggesting that this set of rhythms is momentary, belonging to this face only, and will not occur again. The sculptor Horatio Greenough said some years later that, while beauty was the promise of function, character was the record of function. Each form in West's face seems to have been created by the habits of characteristic action, an action that seems to continue in the harsh interplay of line and contour in the painted portrait.

That such characterizing vitality is not simply a matter of verisimilitude, aided by the convincing effect of light and material solidity, is made evident in many eighteenth-century American portraits that make little pretense of illusion. John Hesselius's portrait of Mrs. Brown is a good example [5]. There is no doubt that this is a portrait, a likeness of a particular individual with

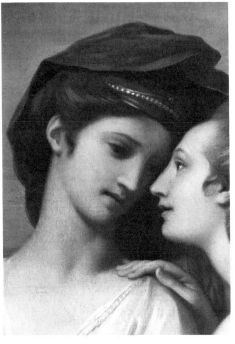

[3] Detail from Benjamin West's *Helen Brought to Paris*. 1776.

[4] Benjamin West. *Self Portrait*. 1819.

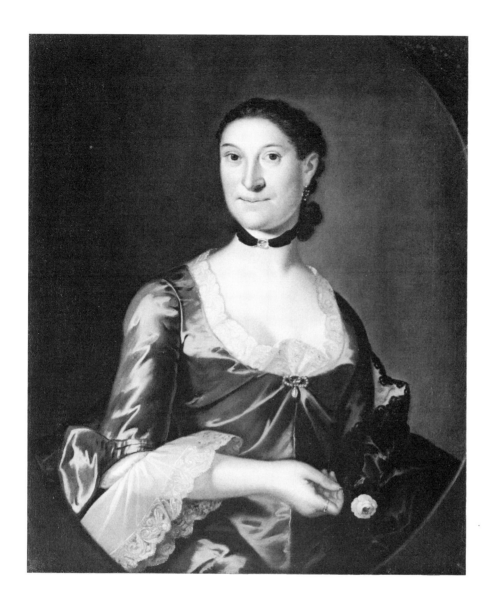

whom we make direct contact. Yet the light is only a convention and does not really create a sense of a particular environment as in the self-portrait of West. The vitality in the face comes from the lively interplay of rather bumptious rounded forms. Each feature vies with another in a kind of jocular exchange and refuses to take its place in a fixed scheme of the whole. This unpredictable interaction seems, as in the West, to spring from

[5] John Hesselius. *Mrs. Richard Brown.* Ca. 1760.

within the sitter, to arise from her particular character. As far as we know, Mrs. Brown may not have been the lively woman this portrait evokes, but here she lives as such a person, not because of what she is doing or because she has a long nose or short, but because John Hesselius found in her features the possibility of this animated play.

It would seem, then, that what we have taken to be portraits and nonportraits can both be described in terms of action. The difference is the nature of the action evoked. In the one case, that of the young women, the motion was clearly controlled by a kind of harmonic system, uninterrupted by accident or eccentricity. Although they exist within this state of harmony, the young women hardly seem to be its creators. They are caught up in a system larger than themselves and are as beautiful as they conform to the system's underlying law. In the others, the action springs convincingly from the peculiarity of the features which seem to create their own system, a system that belongs to this person and to no other. So we recognize a portrait.

Why should an artist want to paint a person who is not a person, who is not uniquely individual? William Hazlitt later wrote that a portrait was the greatest history painting, because it carried the truth of historical action in the unique expressiveness of the candidly rendered face of the sitter. Why would a painter wish to conceal this truth? Truth might be considered on two quite different levels: that of the immediate palpable fact testified to by the proof of the senses: and that of the larger significance to which an isolated phenomenon might only point. What is most true of a tree, the fact that it is an old, weatherbeaten oak, or that its roots, trunks, branches, and leaves express a principle of growth that we recognize as a universal quality not only of *oak tree* but of *tree*? One could ask the same question of an historical action: what is the more significant truth, the fact that Gen. George Washington dressed in a rather cumbersome and rumpled uniform, led his forces to victory against a dispirited group of Hessian mercenaries, or that a courageous, noble man led a heroic band of compatriots in a victorious fight for free-

dom? The answer of many late eighteenth- and early nineteenth-century artists was distinctly in favor of the latter, and it was their belief that the inclusion of particular, detailed facts of the local truth, would obscure the significance of the universal. Truth lay in the realm of understanding, not in the realm of unqualified perception. If art was to speak to the mind, it must adopt a language of the mind, not simply of the senses. If Benjamin West's young women dwell in a world different from that in which his own likeness exists, it is because they belong to the mind, to the realm of moral values. His face is the record of physical being.

Can these two worlds come together? Can, in other words, the life of an individual identify itself with the moral qualities of the ideal world? This could be the definition of a hero: a person whose actions transcend the individual to make him a personification of morality. It could also serve to describe great beauty, as distinct from passing prettiness. At the time of Benjamin West, moral beauty would be that in which attention was not called to the sensuous immediacy, but to a more remote and timeless quality of calm harmony.

[6] Thomas Sully. *Mary Abigail Willing Coale.* 1809.

Thomas Sully's portrait of Mrs. Coale is clearly the likeness of an individual woman who looks at us bewitchingly [6]. Yet she hovers between the remote realm of *the beautiful* and the actual society of pretty Mrs. Coale. Although her individual features are not actually like those of West's two young women, they relate to each other and to the enclosing oval of the head in much the same way. The elongated curves of the eyes and brows are caught up in the same extended rhythm as the neck and the long S-curve that moves through the fur, the shoulder, and the whole delicately lighted figure. Through the force of a formal style, Sully has paid Mrs. Coale a poetic compliment, seeing in her features those qualities of harmony that pertain to universal beauty, yet allowing enough divergence for likeness to be maintained. This is Mrs. Coale in the realm of *the beautiful*. There, she could welcome with equanimity the arrival of Hiram Powers's ideal *Greek Slave* [7].

[7] Detail from Hiram Powers's *The Greek Slave.* First version, 1843.

It is all a matter of how you see [8]. If you look at yourself intently in the mirror you might discern two quite distinct visages. The one is based on a norm of proportion only slightly altered by the particularities of your features, basically symmetrical with one contour nicely bracketing another. The other seizes at once upon the most unusual aspects: a bulging nose, a protruding chin or strong marks under the eyes. Caricature is based on emphasizing these latter characteristics at the expense of all other. But look closely at these peculiarities, and note that they have their own way of working together, much like the rugged features of Benjamin West. In a portrait, if this kind of rhythm was missing, after a few seconds of viewing the image would be as dead as a waxworks.

The idea of art keeping the mind in touch with a higher order of values through the persuasion of harmony was very old, but it came in for an energetic revival during the second half of the eighteenth century, exactly during the period that Pennsylvania-born Benjamin West was painting in London. Sir Joshua Reynolds, whose discourses to the Royal Academy were read with care by aspiring young Americans, advised the artists to train their hand and eye on the sculpture of antiquity and the works of old masters in order to see the universal truth in everything. If the mind responds intuitively to *the beautiful*, then *the beauti-*

[8] Portrait diagrams.

ful in its turn should be able to educate the mind. Since a basic principle of beauty was thought to be regularity and measure, the hand and the eye might be educated to these qualities. Supposing a child began by practicing until he could connect two points with a straight line without a ruler ━━━━ If you have ever said that you cannot even draw a straight line, you were unwittingly referring back to this first exercise in drawing. Then connect the two points with a curve ⌒ ⌣ The points must be drawn first, since the discipline comes in exactly matching the gesture to the space. Now two curves could be put together: ⌒⌣ With this skill mastered, all manner of things can be drawn. These are some pages from an American drawing book [9]. John Gadsby Chapman, who perpetuated

[9] Pages from a drawing book by J. G. Chapman.

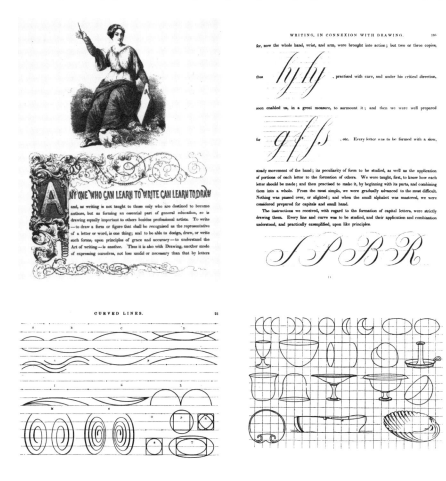

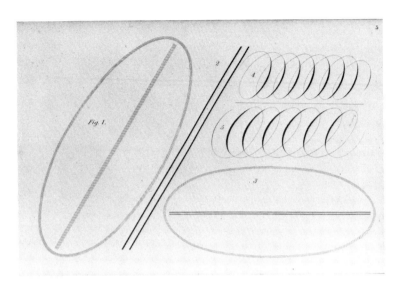

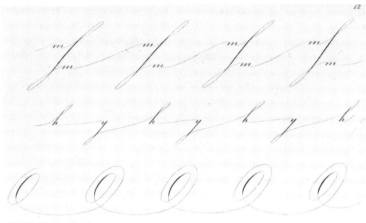

[10] Calligraphy exercises.

these exercises in his drawing book, advertised that if you could learn to write you could learn to draw. In fact, writing was taught in much the same way, with repeated exercises in abstract rhythmical schemes [10]. Good handwriting was not simply a matter of legibility, but was the expression of a confident, disciplined hand which, in turn, reflected a confident, disciplined mind. A child was not encouraged to create a "personal" handwriting; through his measured, beautiful handwriting he showed himself to be a citizen of the larger world of culture. The educational virtues of this kind of method were enthusiastically de-

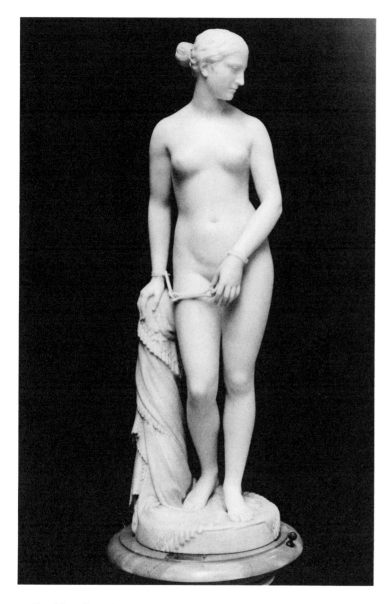

[11] Hiram Powers. *The Greek Slave.*
Later version (first version, 1843).

scribed by the educationist Pestalozzi who identified this propor-
tioned discipline of the hand with the balanced, unperturbed use
of the mind.

When Hiram Powers exhibited his famous marble sculpture of
The Greek Slave in 1847, the question of nudity in art was still
a matter of spirited debate in the United States [11]. Several

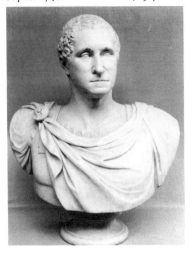 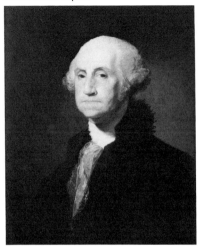 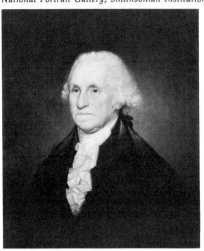

artists in the past had provoked scandals with nude figures. But Powers succeeded in winning acceptance. Although the subject derived from the recent war in Greece, Powers's nameless lady is more remote than that. She is clad in a perfect, disciplined harmony that closes out all untoward physical suggestion; and the mind is free, according to observers of the time, to speculate on the purity of womanhood even in the hands of barbarians. This is a triumph for style.

But the public at large was not always convinced by the transformation of particular flesh into general qualities of mind. For the past almost 200 years most Americans have believed they know what George Washington looked like—at least they could recognize his portrait. Quite rapidly, through the reproduction of his likeness in just about every form imaginable, his face became a kind of hieroglyph even in his own time. If you compare three portraits based on life [12–14], it is evident that the actual features do not agree, but there is a look—an activity amongst the features that we read as a characteristic expression—that served to make up that symbol. Through sheer repetition, this image became Washington. When in 1841 Greenough brought from Florence his monumental sculpture of George Washington commissioned for the Capitol Building, official Washington gasped in disbelief [15]. The familiar hieroglyph of

[12] Giuseppe Ceracchi. *George Washington*. 1795.

[13] Gilbert Stuart. *George Washington*. Undated.

[14] Rembrandt Peale. *George Washington*. 1795.

[15] facing: Horatio Greenough. *George Washington*. 1840.

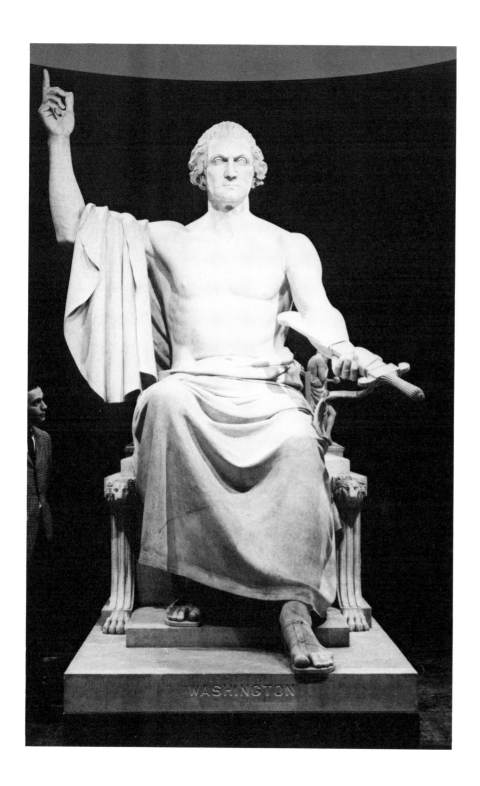

Washington, a household likeness, appeared on the half-nude body of a Grecian god. Even though Greenough had skillfully shaped the likeness to a strong but ideal perfection, the sense of portrait was too deeply fixed in the American mind to permit Washington this visual transcendence. Two worlds suddenly confronted one another: that of the hero which was timeless, in which the Father of his Country could be visually equated with Olympian Zeus; and that of pragmatic values and specific personalities.

Although Greenough's effort was possibly too extreme, too specialized for a broad public, we have persisted even until today in transforming the likeness of our statesmen and politicians in one way or another to suit the dignity of office. For the successful candidate [16], brows are straightened, the shape of the eyes is simplified, and a monumental dignity of proportion gradually pulls the features into place. But a public figure out of favor [17] becomes all nose, wrinkled eyes, and pouchy chin; the morality of proportions has left his countenance.

[16-17] Details from political cartoons about Woodrow Wilson. 1912.

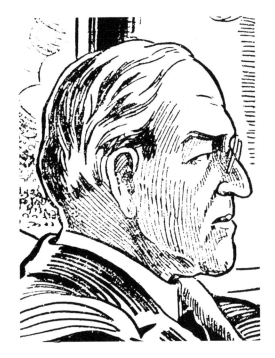 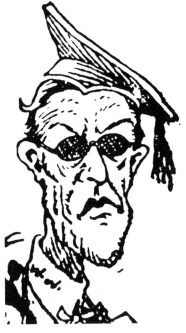

A portrait, then, is a kind of evaluation. It reveals not just the likeness of an individual, but the place the person depicted holds in our consciousness. There is probably no surer index of what we assume truth to be than the rendering of human likeness: whether truth is the ultimate significance of a character or an act, or simply the material fact itself. Through a style, which at the time of Benjamin West and Thomas Sully was called *the grand style* or simply *the beautiful,* the artist could render a likeness as timeless, granting, in his way, a kind of immortality to the sitter; by the same token, he might emphasize the materiality, the mortal aspect of the sitter's existence. For some— for example, West looking at himself in his old age—there is comfort in the acceptance of the simple "is-ness" of things. At least, West, in his contrasting works, acknowledged that there is more than one aspect of truth.

How do you know it's a portrait? How do you know what individuality is or what it's worth?

If you wish to pursue these ideas further—

As a general approach to form in art, *Learning to Look*, by the present author, might prove useful. E. H. Gombrich's *Art and Illusion* (2d ed. 1961) examines many questions concerning the perception of form. Many artists of the epoch were fascinated by the English painter William Hogarth's *The Analysis of Beauty, written with a view of fixing the fluctuating ideas of TASTE*, first published in 1753, which set forth his ideas about a "line of beauty." The idea of a "grand style" was most persuasively argued for in Sir Joshua Reynolds's *Discourses*, his lectures at the Royal Academy in London from 1769 to 1790. The drawing book here referred to by John Gadsby Chapman and first published in 1858, had as its full title, *The American Drawing Book: a manual for the amateur, and basis of study for the professional artist, especially adapted to the use of public and private schools, as well as home instruction*. Robert Rosenblum discusses in detail aspects of style during the period in *Transformations in Late Eighteenth Century Art* (1967). For a more philosophical consideration of the significance of form at the time, see Archibald Alison's *Essays on the nature and principles of taste* (1790), Johann Heinrich Pestalozzi's *How Gertrud Teaches Her Children* (1801) and Johann Friedrich Herbart's *The Science of Education, Its General Principles Deduced From Its Aim, and the Aesthetic Revelation of the World* (1804, 1806). On the nature of likeness, Henri Matisse made a provocative statement, "Exactitude is not truth," in a brief essay reproduced in Alfred H. Barr, Jr., *Henri Matisse: His Art and His Public* (1951) and elsewhere.

Why Paint a Landscape?

The question sounds foolish. Landscapes are among the most common of paintings. They are peaceful, noncontroversial, and remind us of where we would rather be than where we are. A landscape is likely to be the easiest kind of painting to take for granted as simply decoration in the room. Yet the idea of painting a landscape just for itself, not as the background for something else, is relatively new. Only in the nineteenth century did landscape painting really come into its own. For this to happen, something must have changed in the outlook on art; and, of course, it did.

One obvious reason for painting a landscape is for remembrance, to record a place that has been enjoyed or a famous place that has been visited. One reason "view painting" flourished early in Rome was that people on the grand tour wanted souvenirs of their visit. Several generations of painters and etchers, most notably Piranesi among the latter, were kept busy depicting the monuments and environs of Rome to be carried home by visitors, and by the middle of the nineteenth century landscape photography flourished there for the same reason. The face of Rome was well known by many who had never even made the trip, but acquired their nostalgia at secondhand. In the United States, one of the most painted natural phenomena was also one of the most visited and most talked about—Niagara Falls. This thundering, shattering wall of water was painted by Alvan Fisher in 1820 [18], and he made careful notes indicating the exact spots from which he viewed the Falls.

For a phenomenon that was regularly referred to as terrifying, the Falls seems reassuringly calm in this view by Fisher. The great horizontal sweep and the simple uncluttered forms emphasize space and grandeur, not the awful thundering of the cataract. In fact, nature cooperates in a most sympathetic way. Two primly erect evergreens bring the vertical contrast to the hori-

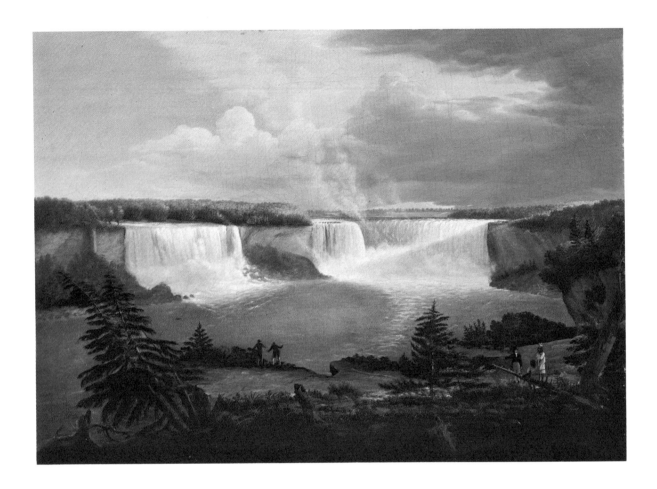

zontal Falls into the foreground, establishing a stable basis for any other rhythms that might occur. The small figures of men help this out—the one explaining nature to the Indians being a kind of diagram of this stable relationship, although the gentleman teetering on the brink suggests a rather less static situation. His precariousness, however, is reflected in nature too, because all of the other trees and stumps ally themselves with diagonal motions pushing either to the right or the left. The graceful group of trees on the left establishes the leftward motion, abetted by two stumps and the right-hand cliff. This is the most persuasive direction since it opens up the expanse back to the Falls and even into the sky, and emphasizes the light that strikes diagonally across. But it is stabilized by a useful snag that leans

[18] Alvan Fisher. *Niagara Falls.* 1820.

purposefully to the right, and by the pall of the dark clouds and profiles of trees on the right-hand side of the painting. Lest the snag be too diversive, a fallen tree at its base points resolutely back to the Falls.

What develops is a gentle opposition of forces existing within a fixed and stable system. Every part in nature cooperates. Even the branches of the erect tree reflect with sympathy the other rhythms of the scene.

That we respond differently to different forms in landscape was a well-established belief by the time Fisher painted this scene. In mid-eighteenth-century England, connoisseurs were fascinated by what they discerned as different modes in landscape and toured the country in search of perfect examples. There were two basic categories, associated with the works of two seventeenth-century painters. The one, based on regular forms existing in simple vertical-horizontal relationships, emphasized the peace and order of nature and calmed the mind. Claude Lorrain was the master of this natural beauty [19], and *the beautiful* was the term applied to this experience of uninterrupted harmony.

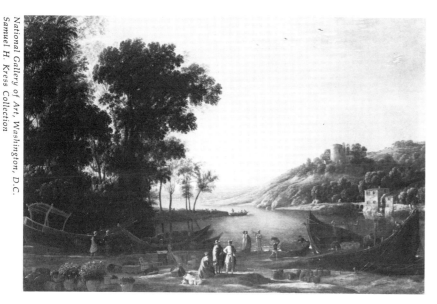

[19] Claude Lorrain. *Landscape with Merchants.* Ca. 1635.

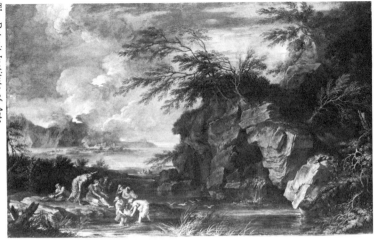

[20] Salvator Rosa. *The Finding of Moses.* 1662/1673.

There was another side of nature, however, that was less re-assuring. A power quite overwhelming to man could manifest itself in storms and eruptions in which all the forces of nature seemed in conflict. Evidence of such strife was to be seen in the gaunt relics of trees struck by lightning, jagged rocks, and the irregular outlines of ruined buildings. Salvator Rosa was the artist whose work best expressed this mode [20], his compo-sitions following the thrusting diagonals and abrupt, jagged forms of nature in a state of evident change. In his essay of 1757, Edmund Burke discussed the fascination with this uncontrollable, overwhelming power that forcefully taught man the humility of his situation, and associated it with what Longinus had called *the sublime.*

The two modes were associated with two aspects of the mind: the intellectual, clearly reasonable faculty and the irrational faculty that operated by insight rather than reason. Both were of value.

So fascinated were gentlemen by this discovery of human mean-ing in landscape, that they planned their estates to reflect and provoke these states of mind. Large sweeps of lawn with grace-fully clustered copses and groves, carefully designed to seem natural but in a harmony of *the beautiful,* contrasted with rocky

glens concealing hidden pools, irregularly placed snags and methodically constructed ruins, where one could pleasurably lose one's way and appreciate the terror of *the sublime*. This seemingly natural garden with its varying modes of expression became known as the English Garden and was much imitated throughout Europe.

At the end of the century, another mode made its appearance. Writers like the Reverend William Gilpin were impressed by the fact that the perception of irregularity of form, of form which seemed chaotic yet had an indefinable sense of unity, had its own attraction. In a way, it freed the mind both from the rational measure of *the beautiful* and the overwhelming effect of *the sublime*. In a puzzling way, it was simply interesting, suggesting an infinity of variation without threatening the stability of man. This mode was dubbed *the picturesque*.

Through its forms, then, a landscape could be mentor to the mind. Although he was painting a cataract, one of Burke's telling illustrations of *the sublime*, Alvan Fisher saw it as an experience of beauty, a wild act of nature encompassed by the reasonableness of the human mind.

These modes of thought underlaid attitudes toward landscape in America for several decades. In 1841, Alexander Jackson Downing used these definitions in setting forth his ideas on rural architecture. He believed that *the picturesque* and *sublime* were more attuned to America than *the beautiful*, but he reserved *the beautiful* its place.

It was probably the search for *the sublime* in American landscape that led to what became known as the first "school" of landscape painting in the country. Thomas Cole, for one, set out to find the most rugged examples of nature in a mood of flux (although, when he wished, he could also turn his attention to *the beautiful*). The composition of his painting of *A Wild Scene* is strange and unsettling, with a thrusting mountain and sudden unfathomable gaps in space [21]. His plan of construction is

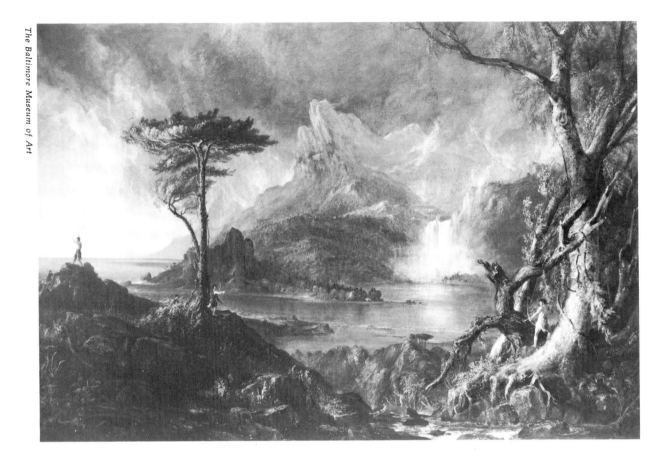

skillfully concealed in his jagged forms, and the effect is a scene not readily measurable by the eye and seemingly unexplored by man. The human figures are primitive men whom Cole obviously considered a part of the natural order. There is a quality in the twisted tree at the right that suggests an additional content in Cole's picture [22]. To be sure the snag is in the best tradition of sublime snags, but there is a peculiarly involving power in its rhythms that gives it particular drama. The dead tree is more alive than the figure at its base. It is as if each reaching branch were a gesture of Cole himself, as if he had not so much depicted the tree as acted it out. In a sense, this histrionic quality was common to *the picturesque* and *sublime* which denied the observer a psychological distance from the thing he saw; but in this instance, Cole's intensity is such that the agonizing forms

[21] Thomas Cole. *A Wild Scene.* 1831–1832.

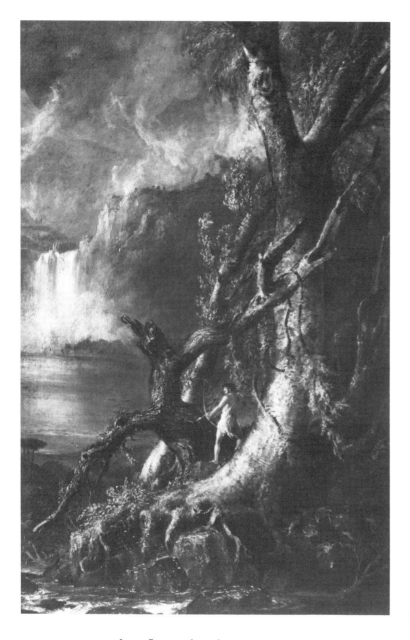

[22] Detail from Thomas Cole's
A Wild Scene. 1831–1832.

express a personal conflict within the artist rather more than a
struggle of nature. Nature became the arena in which, on cosmic
scale, the moral life of man was enacted. Every twisted tree,
each billowing cloud or burst of sunlight, was for Cole the
reflection in a deep personal sense of a moral state.

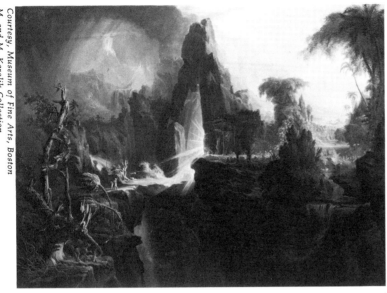

[23] Thomas Cole. *Expulsion from the Garden of Eden.* 1827–1828.

[24] Thomas Cole. *The Pilgrim of the Cross at the End of His Journey.* (Study for the series *The Cross and the World.*) 1844–1845.

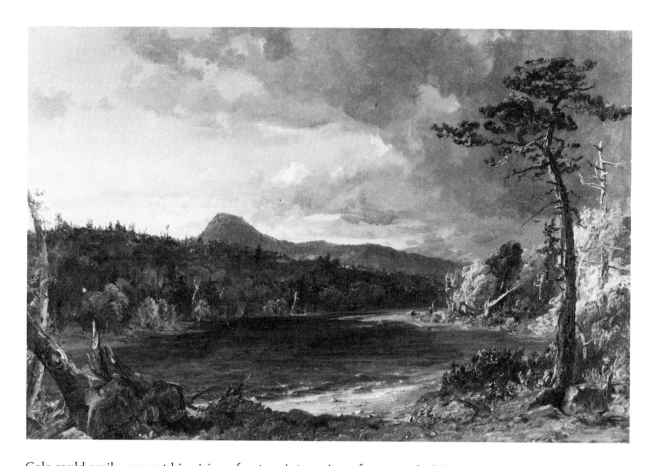

Cole could easily convert his vision of nature into a view of
Eden or the moral waste of earth beyond Paradise after the fall
[23]. And yet his vision was based on the actual nature around
him which he studied in great detail. With the glow of evangeli-
cal fervor, he saw the Catskills as an expression of his own inner
life, and his own inner life as a microcosmic version of the
struggle of man. Looking at his depiction of *Pilgrim of the Cross
at the End of His Journey* [24] is like participating in that cli-
mactic moment at which the sun breaks through the storm
clouds in the mountains; yet for Cole, the sun became the Cross.

Some of Cole's histrionic vigor is still apparent in a painting
such as Jasper Cropsey's landscape of 1850, but there is none
of the religious overtone [25]. It is a direct vision of nature
translated into vigorously manipulated paint. But a change was

[25] Jasper Cropsey. *Catskill Creek,
Autumn.* 1850.

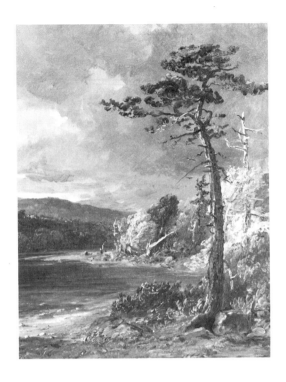

already taking place even in the direct visualization of nature. If we compare a detail from this painting [26] with the section of a painting by William Trost Richards of 1861 [27], it is apparent that the two painters saw nature in very different ways. Cropsey evoked the general effect of a landscape with lively brush strokes that have a vigorous life of their own. It is easy to suspect the strokes of repeating formulas that Cropsey had found useful before in rendering brush or foliage or clumps of trees. In the Richards, brush strokes are wholly at the service of the specific foliage being rendered, and there is no suggestion even that the various leaves on a single tree should necessarily be painted in the same way. The artist did not bring to the scene a vocabulary of forms which could be adjusted to the circumstances, but sought to catch the peculiarities and nuances of the effects he saw. This is equally true of the whole composition [28]. There are no conveniently placed snags or clumps to frame the view and create a pocket of controlled space. Richards chose his situation carefully, and convinces us that his composition was actually seen, not constructed.

[26] Detail from Jasper Cropsey's *Catskill Creek, Autumn*. 1850.

[27] Detail from William Trost Richards's *Trees Along the Stream in Fall*. 1861.

This change has important implications. Cropsey was following a very old tradition. How to draw trees of various kinds, what sort of a hooked line to use for foliage or enclosing lines for bosky groups, were included in numerous drawing books from the late eighteenth century on [29]. To be sure, the artist went to nature to study, but he went prepared. It was not until the late 1840s and '50s in the United States—the change had taken place earlier in Europe—that a complete absorption in the thing seen overtook the traces of construction by formula. In attempting to paint natural objects in their full particularity, the artist was in effect saying that nature, simply as it appears, provides adequate content for art without the necessity of including any trace of man's emotions or inventiveness.

What, then, was art's content?

[28] William Trost Richards. *Trees Along the Stream in Fall.* 1861.

[29] Drawing book illustration of foliage.

[30] Asher B. Durand. *Kindred Spirits*. 1849.

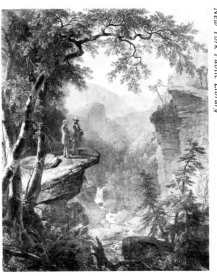

In 1849, Asher Brown Durand painted a landscape [30] commemorating his friend Thomas Cole who had died the year before, showing him and the poet William Cullen Bryant standing together on a rock, surrounded by a verdant wilderness. *Kindred Spirits*, Durand called his work. Although an obviously composed painting, it is a dispassionate one, suggesting that simply to be within the precincts of wild nature was enough to sense the community of spirit between the two friends and their mutual inspiration, Nature. The widely read words of John Ruskin, published first in defense of Turner in 1843, made sense to many American painters. For Ruskin, even Claude and Poussin were at fault for interposing themselves between the viewer and God's nature. Nature, the infinite creation of God, in all its changing manifestations, was the appropriate content, not the means, for art. Any tampering with nature as seen was a kind of sacrilege. Ralph Waldo Emerson went so far as to call art just "the gymnastics of the eye" by which the eye is taught to see nature in all its truth. One did not so much look at the painting as through it, to the realm of nature beyond.

Thus when Frederic Church sought *the sublime*, it was not in jagged formal constructions or a stock vocabulary of objects. He looked for the most extraordinary features of the earth and painted them in such a way that they retained their earthly sub-

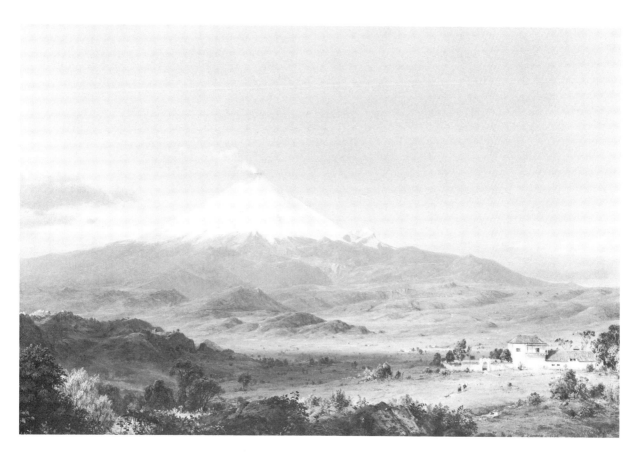

stance, even when their vastness overwhelmed. There is no single way into the space of his *Cotopaxi* [31], no accommodating pointers or guides as in Fisher's view of Niagara. One is simply in the space, and it stretches out on all sides. Concentrate on any point, on the man and his two burros, for example, and an extraordinary space surrounds you. The painting affords a multiplicity of experiences, like being surrounded by nature itself.

This use of painting to thrust the viewer into the midst of nature, to wander through its vast spaces and wonder at its complexity, continued in America for several generations. Explorations in the West provided ample material for painters such as Albert Bierstadt [32], who first went to the West in 1859, and later for Thomas Moran [33]. When the area of the Yellowstone

[31] Frederic Edwin Church. *Cotopaxi.* 1855.

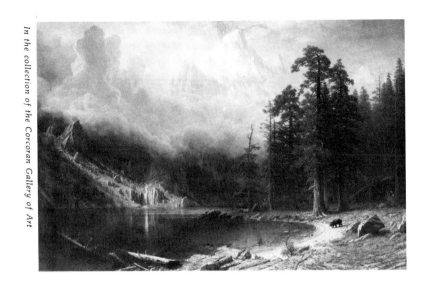

[32] Albert Bierstadt. *Mount Corcoran*. 1875–1878.

[33] Thomas Moran. *The Grand Canyon of the Yellowstone.* 1893–1901.

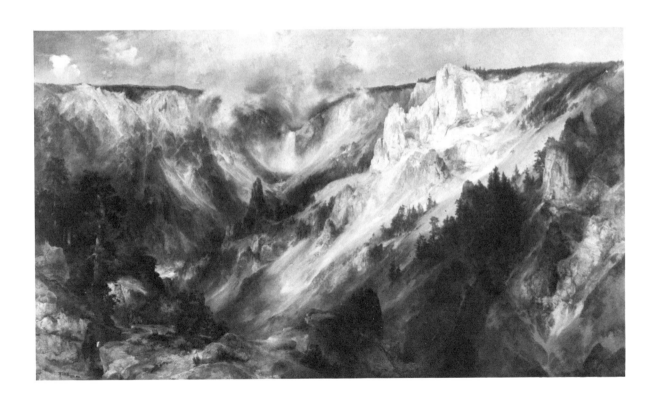

was declared a national park in 1872, this sense of landscape was confirmed in terms of nature itself. The national parks became unending pictures without frames.

Although the little painting by Richards [34] allows the viewer to wander and discover at will, the discoveries are not so startling as in Church, or Bierstadt, or Moran. The scene is modest; the day simply pleasant. What fascinates is not the objects themselves but what is happening to them in the warm light, as their pink and lavender lights and shadows mingle with reflections in the smooth water. It is an idling picture, in its way. We are not pushed to draw any conclusions about higher meanings or moral significance, nor even to worry about geological niceties or species of plants. It is enough simply to lose oneself in the pleasures of looking, in the seemingly infinite variety that light provides.

In quite a different way, that is also true in Samuel Colman's more ambitious painting of *Storm King on the Hudson* [35]. The

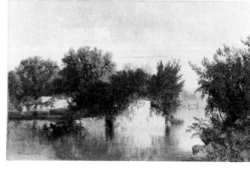

[34] William Trost Richards. *Trees Along the Stream in Fall.* 1861.

[35] Samuel Colman, Jr. *Storm King on the Hudson.* 1866.

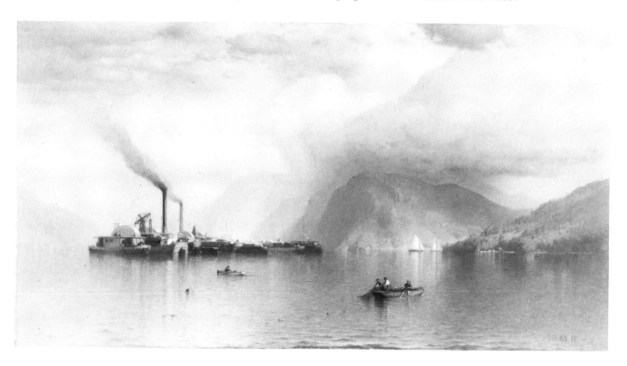

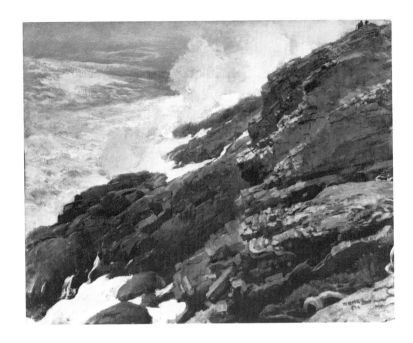

[36] Winslow Homer. *High Cliff, Coast of Maine.* 1894.

sharply defined boats and floating objects seem suspended in the calm, luminous space. There seems to be an uncertain number of translucent veils, among which we somehow lose ourselves. But in the process of getting lost, we discover much: the sailboats in the quiet cove, the half-lit hills, the hints of life in the community of boats. The most rewarding discoveries, however, are the varieties of shimmering light and color which refresh the perception, awakening enthusiasm for our sense of seeing.

This need not be a vaporous pursuit. Once we become aware of our perception—how we see a thing instead of, or in addition to, what the thing is—all manner of new experiences can hold our attention. In Winslow Homer's painting [36], for example, the simple forms created by the momentary vision take on a structure of their own, creating a surprising feeling of almost breathless equilibrium, fixed by a glance. To encounter this seemingly unconstructed but undeniable poise within the free-wheeling process of our perception strikes us as a happy miracle, a moment of unimposed order in a chaotic visual world.

Sometimes, however, a painting can deliberately create a sort of

visual chaos to intensify our awareness of perception itself, making the pursuit of order or of a telling nuance all the keener. For example, in John Twachtman's *The Brook, Greenwich, Connecticut* [37], there is no question of the general disposition of the landscape, of the winding stream pushing its way through the snow. Yet the more one looks, the more one discovers particularities, not in the definition of objects—they remain undefined—but in the happy coincidences of color, such as the scattered pattern of hardly discernible golden leaves against the mottled blue-gray snow, or the strange green that becomes brown before we can isolate it as a green. It is in this surprise of discovery, in the shifting and changing, that the pictures lives.

[37] John Henry Twachtman. *The Brook, Greenwich, Connecticut.* 1890–1900.

In some ways this is like the experience afforded by some of the French painters who were called "impressionists." They were initially scorned because they delighted in the complexity of looking, rather than in defining the forms of things seen. This was the conflict of two notions of reality. Is reality made up of those objects which we assume to exist in their totality outside ourselves (in fact, we can prove their objective existence only by formulating concepts about them); or is reality to be found by investigating the nature of our perception? It is on our perception, after all, that any judgment of the outside world must inevitably be based. Fortunately, one does not need to choose exclusively between the two, although critics in the 1870s and 1880s thought they must. To relinquish hold on definition and measure as a proof of reality was held to be a threat to all that was dearest to the human mind. But Theodore Robinson's little painting from Giverny [38], where Monet also painted, now seems hardly a threat. To be sure his evident brush strokes do little to define objects, nor do they create dramatic gestures as in the works of Thomas Cole. They float in the sunny atmosphere, becoming trees or flowers or shrubs as you wish, conjuring up neither recollections of the past nor premonitions of the future, but inviting one simply to be, to live for a moment in the free

[38] Theodore Robinson. *Old Church at Giverny*. 1891.

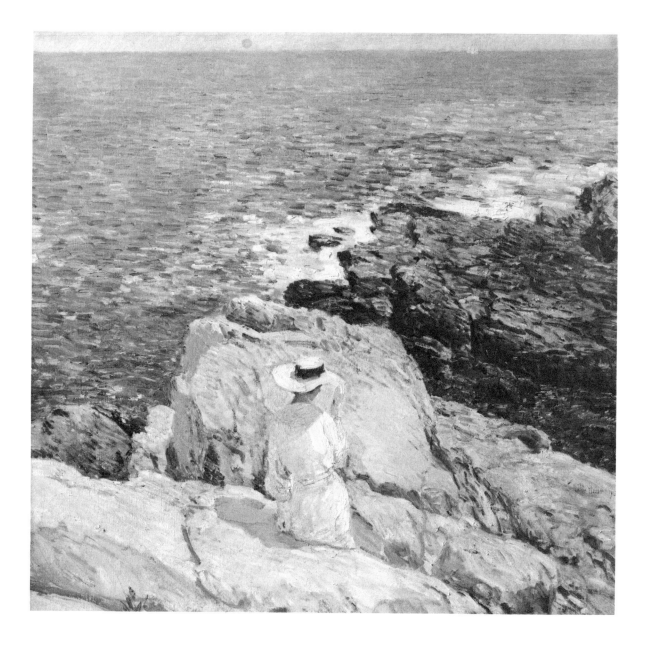

flux of perception. Landscape, so winningly rendered, provides for a new freedom of the mind.

Characteristically, Childe Hassam's lady turns her back to us as she sits on the rocks next to the bright blue sea [39]. Neither

[39] Childe Hassam. *The South Ledges, Appledore (Sunny Blue Sea)*. 1913.

she—nor we, for that matter—are the subject of the picture. We are encouraged to lose our identity for a moment, to become one with the rocks and sea and dazzling sun. It is not, as in a painting by Church, that you are located in a space and seem to be looking around you; in the Childe Hassam you are everywhere at once, or no one place at all. For the moment, through the brilliance of the color and the complexity of forms, our active perception is totally engrossed. Any distance that we assume should exist between observer and the thing observed, the measures of a monitoring mind, collapses in a unity of experience that leaves no time for questions or analyses.

Why paint a landscape? There have been so many reasons and there will be many more. We have examined chiefly three: as a language of the mind, both to teach and reflect the pleasures of order and the equally significant pleasures of symbolic conflict and destruction; to lose one's self in nature and bring about a deeper understanding of nature as the manifestation of God; and, lastly, to find in the conscious exercise of perception a new bond with the world around, a new value in the process of being.

If you wish to pursue these ideas further—

Barbara Novak in *American Painting of the Nineteenth Century* (1969) discusses some aspects of American landscape painting in detail. There are, in addition, monographs on individual painters and movements. For general considerations of landscape painting, Sir Kenneth Clark's *Landscape Into Art* (1949) is an engaging work. *Nature and the American* (1957) by Hans Huth is a provocative study of attitudes toward nature. William Gilpin in his treatise *Three essays: On picturesque beauty; On picturesque travel; and On sketching landscape; to which is added a poem, On landscape painting* (1792), discusses the fascination of irregularity in natural form. Andrew Jackson Downing in his *Landscape Gardening and Rural Architecture* (1841) applies the categories of landscape painting to actual garden design. John Ruskin's *Modern Painters,* the first volume of which came out in 1843, was of great interest to American landscape painters. The poems of William Cullen Bryant, especially "Thanatopsis," and the writings of Ralph Waldo Emerson, such as his essay "Nature," were hailed by the artists as expressing their ideals. *John Ruskin and Aesthetic Thought in America 1840–1900* (1967) by Roger Stein is an illuminating study of Ruskin's impact. John McCoubrey's *American Art, 1700–1960. Sources and Documents* (1965) is a helpful anthology of theoretical material.

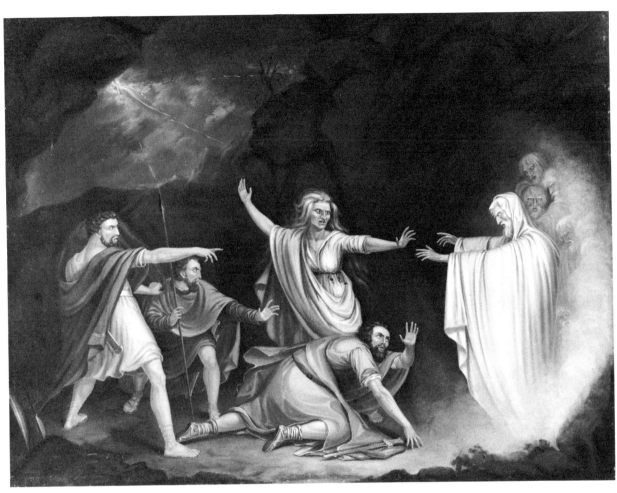

[40] William Sidney Mount. *Saul and the Witch of Endor.* 1828.

To Tell A Story

There has been a great deal written and said over the last good
many years against literary values in the visual arts. In fact,
the literature in support of the nonliterary has become an artistic
subject matter in its own right. But a distinction should be made
between a painting or sculpture that depends for its quality on a
literary source and, perforce, never measures up to the book,
and a pictorial narrative.

Visual narration has a long and respectable tradition and is not
to be confused with simple illustration. As does a story, it invites
the audience to participate in an action. In spite of what some
theorists have said, painting as well as music and literature can
exist in time. To be sure, when you look at most paintings or
sculptures the whole is immediately present, but there is more to
a work than meets the eye at first glance. Two useful questions
in encountering a work of art are: how does it strike me; and
what happens when I continue to look. In some instances, the
attention is frozen, held in a visual silence; but in others, the
attention engages in a more or less systematic pursuit, sometimes
to a conclusion, sometimes not. Narrative, of course, belongs
to the second of these categories.

When the young William Sidney Mount set out to paint *Saul
and the Witch of Endor* [40], he was aware that he had a story
to tell, not just an event to record. Like many inexperienced
storytellers, he was possibly a bit too eager, afraid that his audi-
ence might miss the point. Be that as it may, there can be no
question about the combined attraction and repulsion that char-
acterizes this strange encounter. A ghost has just appeared, and
all but he seem perturbed by the fact; yet everyone is drawn to
him. The faces are all more or less alike, with their staring eyes
and half-opened mouths; the real expression of the painting lies
elsewhere. The stage is set by a static opposition between the
pointing figure at the left and the quiet figure of the ghost at

[41] Detail from William Sidney Mount's *Saul and the Witch of Endor*. 1828.

the right. The soldier's outstretched hand seems to meet its foil in the reaching hands of the ghost. But his motion is more a thrust than a simple gesture. To seem to push so vigorously requires a countering force, something to push against, and a whole series of diagonals pushing to the upper left charge the springs that cause the gesture to thrust forward. In the midst of this pushing and retreating of vigorous lines crouches the groveling figure of Saul, the foreground figure in the yellow cloak. He lurches forward in a long curve (echoed, by the way, in the cloak of the rear attendant) that dramatically stops short as it runs up against the strongest backward movement of all: the continuous diagonal that seems to pull Saul's gesture back-ward and tie it to the upward line of the witch's cloak and arm [41]. An empty spatial barrier is created beyond which nothing

seems to be able to push, isolating the ghost from the other characters. A kind of spark gap is established, punctuated by hands; the hand of the witch, the two hands of the ghost, and the flat, upraised hand of Saul meet those of the ghost. This is the awful moment, the still climax of the action. None of the figures can be separated from the action in which they are involved, but the weight of meaning lies with Saul.

And well it might. King Saul, who had forbade the practice of witchcraft, in desperation went in disguise to the famed Witch of Endor to learn of his future (this is described in 1 Sam. 28:3–20). She summoned the ghost of Samuel who revealed the dread information that Saul would better not have known. It is a moment of horror, willed for and yet repented, in which a mortal man learns more than his mind can bear. The attraction and repulsion we have acted out has specific meaning beyond the melodramatic terror it provokes in itself.

It would seem then, in this narrative language, that through the opposition and support of parts, we are led through a dramatic activity that reaches a climax in a significant, fixed encounter. The moment of encounter is remembered, it is branded on the mind, but it would not be an encounter without the dramatic activity that supported it.

In an essay published in the great French encyclopedia of 1777, the writer Marmontel likened the plot of a literary work to a machine, each part of which contributed purposefully toward the operation of the whole. A few years later, an Italian theorist, Francesco Milizia, took over the description, almost word for word, to describe composition in painting. While what the machine produced was important—the emotional or intellectual impact—the machine itself was an object of some fascination. The plot, in other words, had its own attraction, quite aside from what it told about. But before one could enter into the machine, to will it to function, one had to be interested. That is, he had to be willing to commit himself to the plot's action. The question is, what is necessary to strike this note of interest so that the

perceiver can reap the aesthetic satisfaction of the plot—or, in painting, the active composition. This relationship between subject matter and the activity of forms was much debated by several generations of painters. Composition was not simply a rack upon which to hang a subject. Different narratives required a different involvement of mind and, for this purpose, a different functioning of the "machine."

Mount was composing in the great tradition of history painting, although he was indulging in some shocking elements of what in the eighteenth and early nineteenth century was called *the sublime*—the jagged contours, the gloomy atmosphere, and the emotion-contorted features. The *heroic* or *beautiful* mode was designed to impinge more subtly on the emotions, creating a reserved distance between the observer and the action, even when depicting a scene of anguish and urgency.

In his 1776 painting of *Helen Brought to Paris* [42], of which we earlier examined a detail, Benjamin West showed his suave mastery of classical narration. For all its suavity, however, the principle is not far different from that of the young Mount. In a complex of contours that move forward and back, the chief "plot" of the painting is established in the right two-thirds. The celebrated Helen of Troy gently reaches forward, but the lines of her head and drapery pull her back. Venus, the goddess on Helen's left, leans forward encouragingly, and her gesture is translated into a cupid who, like a blunt arrow, propels the reluctant lady to her waiting lover. It is unnecessary to know just where or how Paris is sitting; it is enough that he melts into a bracketing curve toward which the action is directed. So easy is the motion, so lacking in conflict, that the whole scene seems to take place in a dream. The tiny bits of detail appear and disappear without calling attention to any texture or thing that would suddenly demand its own existence. Only Paris's face makes one wonder if the dream may belong to a particular man.

Some years earlier West had used this method to present an actual contemporary event, *The Death of Wolfe* [43], and was

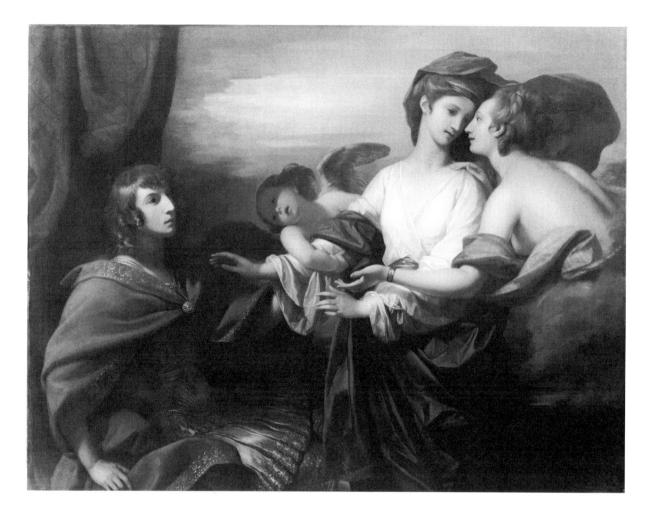

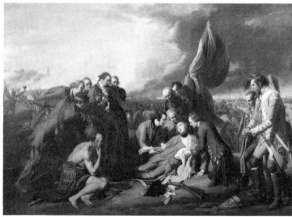

[42] Benjamin West. *Helen Brought to Paris.* 1776.

[43] Benjamin West. *The Death of Wolfe.* 1771.

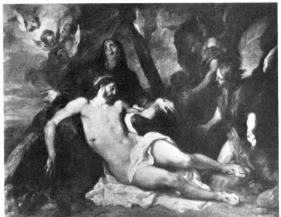

criticized for using modern costume instead of timeless drapery. With modern dress, it was thought, the proper "distance" could not be created to grant intellectual significance to the event. But the way the story was told had more than just style in its favor; the composition itself recalled other narrations of heroic death— the death of Meleager [44], of countless saints, and even of Jesus Christ [45]. By virtue of the composition, General Wolfe died in good company. The form that narrative takes, then, can pique the memory and enlist the support of other reaches of the mind. A kind of iconography of composition can be an important element in giving historical status to any happening.

By the beginning of the nineteenth century, however, a new concept of what constituted history was beginning to make itself felt. A hint of change can be found in Col. John Trumbull's patriotic scenes of the Revolution [46] in which specific people, painted with an effort toward exact physical likeness, take part in specific battles, although composed according to established compositional rules. His spirited paintings are a curious mixture of the here and now, and the timeless reaches of history. It is hard to say whether he elevates the local event to an historical plane, or brings the machinery of history down to the ranks of the everyday. Possibly, he believed that a deliberate confusion of the two best suited his purpose.

Some, however, began to question the whole concept of the hero

[44] Engraving after Charles LeBrun. *The Death of Meleager*. 1658.

[45] Anthony van Dyck. *The Lamentation*. 1634.

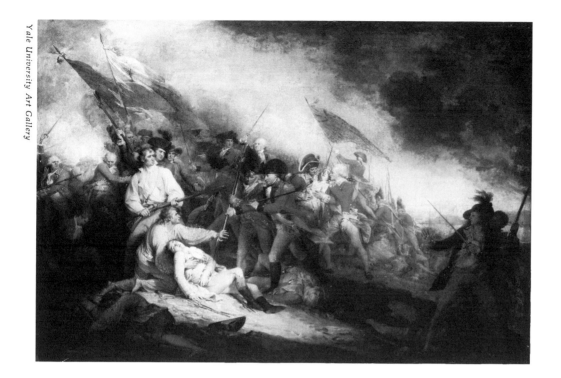

and his elevated, moral realm of action. The idea of history as a series of heroes began to pall, for artists and historians alike. Some painters preferred to frame the activity of their works within the limits of the local environment. History, to them, became the recording of an actual event, and the event was not the proving of a heroic personality. On the contrary, it often deliberately shunned the heroic. While earlier, accuracy meant the unerring matching of the correct form and the most persuasive composition to the moral significance of the act portrayed, some now insisted that accuracy meant only the correct reporting of actual fact. This had many ramifications. For example, in the theater, costume had always meant simply a kind of fancy dress, suitable to the mode of the play, tragic or comic. Only in the late eighteenth century did an actor playing a noble Roman appear in a toga. Shortly, something approximating period dress was expected in classical drama. This new sense of period accuracy gradually spread from a concern for the accurate depiction of the ancient world to the study of other periods as

[46] John Trumbull. *Battle of Bunker's Hill.* 1786.

[47] Costume plate. 1843.

well. The idea of "costume" as specifically significant ap-
parel also began to invade the realm of everyday dress, and by
1830 rebellious young men could publicly express their position
by adopting what they thought to be medieval elements in their
haberdashery [47]. These young men felt that they could actually
live within a past period by choosing the style of their dress and
redesigning their environment. Instead of flattening out the
chronology of history by elevating it to a timeless moral plane
in which heroes spoke only to heroes, artists and historians now
delighted in discovering the peculiarities of the past, particulars
that would allow them to enter into the common life of the
earlier time, to be in the past as if it were the present.

Emanuel Leutze's *Washington Crossing the Delaware* of 1851
[48], ten years later than Greenough's unfortunate statue, pre-
sents quite a different category of experience than West's *The
Death of Wolfe* or even Trumbull's *Battle of Bunker's Hill.*

54

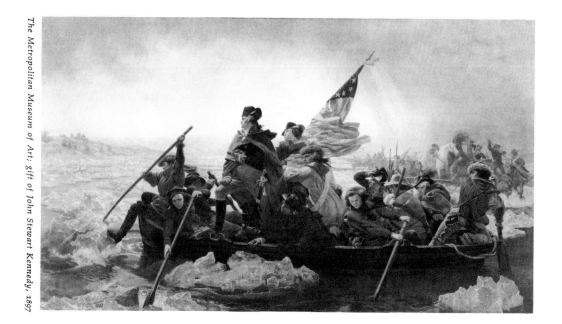

[48] Emanuel Leutze. *Washington Crossing the Delaware.* 1851.

Although he is not dealing with a contemporary event, as they were, Leutze offers a more convincingly accurate picture of what the event might actually have looked like than either of the other two. Compositionally, it is a heroic picture in the highest tradition, with every form and line building to the figure of Washington as he enters upon his bold adventure. Along the way, however, there is all matter of homely detail to be gleaned, from the carefully rendered uniforms to the individual character of the oarsmen. Nothing is generalized or left to chance. It is as if Leutze were pointing out that heroic acts take place in a mundane, material world—the only world we know—and yet they still are nonetheless heroic.

If the past could exist as fact, each period having its own character, then the present could exist as present. By the 1830s, artists in America began to make the most of this discovery. Furthermore, the present belonged as much to America as to anyone, while the past belonged, for the most part, to Europe. So the satisfactions of pictorial narrative and all the pleasures of aesthetic machinery found a new location, a new source of interest. Ten years after painting his *Saul and the Witch of*

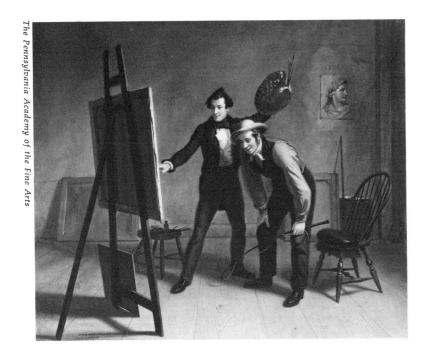

[49] William Sidney Mount. *The Painter's Triumph*. 1838.

Endor, Mount depicted *The Painter's Triumph* [49]. While a drawing of the head of the Apollo Belvedere on the wall looks scornfully away, the artist puts the final touch to his work with the evident approval of his sporting friend. Art, asserts Mount, can exist in the realm of buggy whips and Windsor chairs. In a way, one is reminded of the painting of Horace Vernet's studio executed a few years earlier which showed the artist at work while surrounded by boxers, fencers, a bridled horse, and a helpful friend pounding on a military drum. The world of art and the world of present action were to become one and the same.

But this is only the setting for art, not the art itself. Baudelaire wrote a few years later that the artist should see the world with the eyes of a child or a convalescent, as if everything was seen anew and merited investigation. Such a view Mount had, but observation is only the means for his narrative, which is told with all the assurance—and much more subtlety—that he had displayed in depicting *Saul*. The three-way conversation between the easel, the painter, and the appreciative spectator is lively but

poised, so nicely arranged that their interrelationship cannot be missed. Even the classical head—which figured in the beginning of the whole tradition—appears at just the point his comment is needed. Every line and form is no less occupied in establishing the point of the story than they were in West's *Helen Brought to Paris,* but everything seems to operate quite by chance. We are persuaded that it just happens that the back of the chair, the curve of the buggy whip, and the tilt of the hat make a jocular interplay—or so it seems. Each object depicted has its own identity, its own capacity to stir recollections and invite individual study, but at the same time it plays its part in the formal organization of the whole. Everything belongs to a larger world of things, but at this moment each lends its support to this particular story.

As a recipient of our attentions, an object can sometimes take on a surprising range of meaning in its own right. A well-used chair can recall to the willing mind a whole history of people who sat in it, and a scarred table carries with it the memory of past feasts. To be sure, the mind must be prepared, but enough experiences are held in common that anyone who has not had his powers of association purged by effective education will recognize at once that a carefully selected object is much more than meets the eye. The attachment of emotional meaning to an object through this kind of recollection and association is called sentiment and, twentieth-century strictures notwithstanding, is not to be feared. On the whole, Mount was not much of a senti- mental painter; his objects contribute more through form than through recollection, although he obviously preferred the well used to the new. But for some painters by mid-century, it was enough to set forth a careful selection of objects with their associational overtones, and the reader could spin as many stories for himself as he liked.

When George Lambdin depicted two young women arranging flowers [50], he did not suggest that this was a significant moment in a narrative. With quiet concentration, the two young women simply arrange flowers in a vase. What are they thinking about? What do the flowers mean to them? What, indeed, do

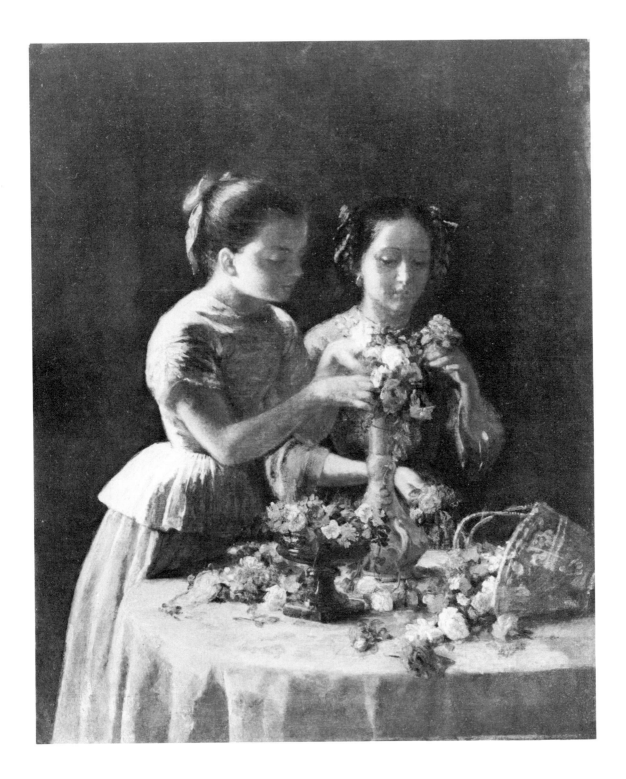

the flowers mean to us? We can talk about the harmony of color, the unusual juxtaposition of tones, or the simple but elegant lines of the young women; but the flowers remain flowers, not just tasteful colors. This quiet moment in the shadowy interior, fragrant and intimate, invites speculation and remembrance. This is a sentimental picture, not because it tells a sentimental story, but because it awakens a sentimental awareness—an awareness that on occasion the ordinary things of our unspectacular environment provoke an indefinable pleasure that lies outside expressiveness of form or aptness of narration. They transcend themselves in our ruminations, as we make of them what we wish.

Frank B. Mayer's painting of Squire Jack Porter (*Independence*) presents quite a different situation [51]. There is nothing lush or winning in this environment as compared to the painting by Lambdin. Yet, fascinating it is because of what we assume to be the character of the squire. There is a spareness about the

[50] facing: George C. Lambdin. *Girls and Flowers.* 1855.

[51] Frank B. Mayer. *Independence* (Squire Jack Porter). 1858.

rather angular forms, the hard surfaces, and the undramatic color that we quickly associate with the man seated at ease with his corncob pipe. Every object is scrutinized with an uncompromising eye, and each thing fits in form and character the assembled whole. It is hard to look long at the painting as a single impression, because some object—the knitting in the window, the broken sill, the well-worn trousers covering the rangy legs which seem to identify themselves with the hand-hewn railings—attracts our attention. And out of this succession of observations, we build our story. This is a story of character, not of action or environment, and Mayer has succeeded in concealing his plot structure so well that we think it is our own. *Independence,* he called the painting, a title which might very well confirm our own response.

The delight in entering the day-to-day lives of others "no greater nor lesser than ourselves" produced the market for an unusual enterprise in art just after the Civil War. Across the country, families adorned their homes with small sculpture groups, made and sold by the ingenious John Rogers [52]. The small figures go about their business without concern for the spectator, wrapped in their own environment. But what creates this detached environment in which we are invited to lose ourselves? These are three-dimensional objects existing in our own space, representing things we know well, yet they seem detached from the larger world of physical consequences. Again, they are invitations to remember and savor.

A part of their charm is their size. Like Alice after nibbling the mushroom, we shrink to enter a new world; different, yet like our own. The concentration on smallness effectively cuts out the actual world around. But then the special nature of this new environment begins to make itself clear: every object and form has given itself over to this act and this moment. We are recreating visually for ourselves a well-told story.

Checkers Up at the Farm [53-56] provides a game that everyone can play. As in Mount's painting of *Saul*, there is a climactic mo-

[52] facing: John Rogers. *The Favored Scholar.* 1873.

60

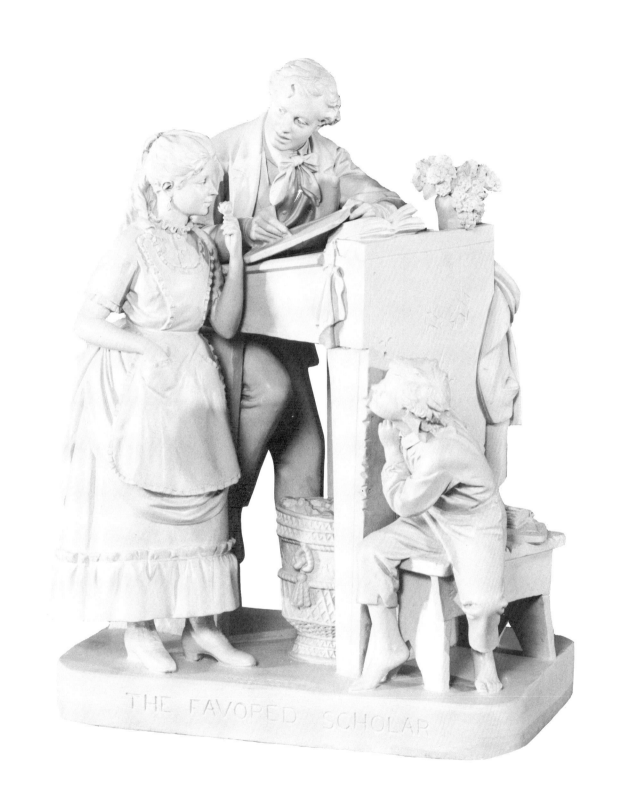

THE FAVORED SCHOLAR

[53-56] John Rogers. *Checkers Up at the Farm.* 1875.

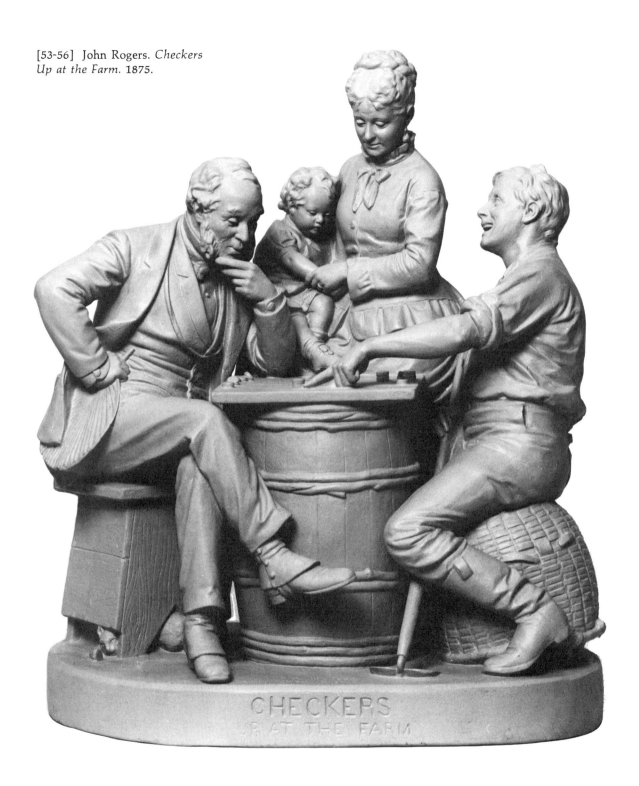

CHECKERS
UP AT THE FARM

ment, but less dire in consequence. It is a triumphant moment of checkmate. No matter from what point of view we approach the work, our attention winds up at the point of confrontation between the bemused gentleman and the jubilant farmer. Rural wit has bested the city. But the contest has been carried on by more than two unidentified gentlemen of obviously different social backgrounds. John Rogers has played his game through an ingenious interplay of rounded forms and rectilinear, beginning with the square board on the round barrel, or the square stool of the gentleman and the rounded basket of the farmer. Roundness here seems to be a rural trait. Walking around the piece, we can follow a complex argument between straight and curved, whether it is the roundness of the child whose arm and foot happily enforce the play, contrasted with the angular arm of the mother—obviously a partisan of the gentleman—or the oval palm-leaf fan that brings curve and texture of the basket into the gentlemanly camp. There are useful invasions: the hoe which repeats the line of the stool—and helps prepare the thrust of the winning finger—and the soft, rounded cat that carries on its own game in the tidy precinct of the gentleman. This game of forms goes on and on, not cut short by the checkmate, creating a narrative context of thought that makes a single event into an endless story.

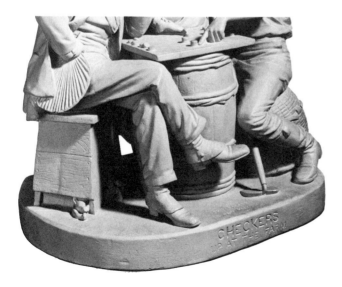

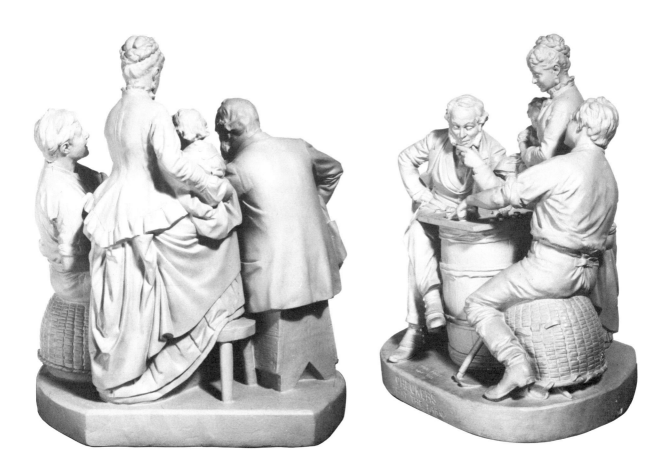

The theory of Marmontel that looked upon literary composition as a well-organized machine is not essentially foreign to this little work, although Rogers's sculpture operates in an environment Marmontel could hardly have imagined. The game of checkers catches our interest; from then on, we are caught up in a visual play of elements that spins out a narrative as complex and continuous as we wish to make it.

Narrative art, then, has its particular visual satisfactions and its own means, comparable to verbal storytelling yet not the same. At its best, it becomes a source for a narration that needs no words yet has a kind of literary continuity and consistency in its form. Like literature, visual narrative may concern itself with

incident, the sentiment of things, character, and, in a sense, plot, yet it develops all of these elements in its own visual terms. Illustration, which is a respectable art in its own right, furnishes the complement to a preexisting verbal account. The works of art we have looked at are quite different. They create the basis for a story that we tell ourselves.

If you wish to pursue these ideas further—

Hermann Warner Williams's *Mirror to the American Past: A Survey of American Genre Painting, 1750–1900* (1973) presents a thorough picture of narrative painting in the United States. Academic theorists set forth rather fixed principles for pictorial narrative, some of which were incorporated into Sir Joshua Reynolds's *Discourses*. Rensselaer Lee's *Ut Pictura Poesis: The Humanistic Theory of Painting* (reprinted in 1967) discusses the tradition which translated literary into pictorial rules. A series of texts that many American artists followed for composition were John Burnet's treatises including *Practical Hints on Composition in Painting* (1822) and *The Education of the Eye With References to Painting* (2d ed., 1837).

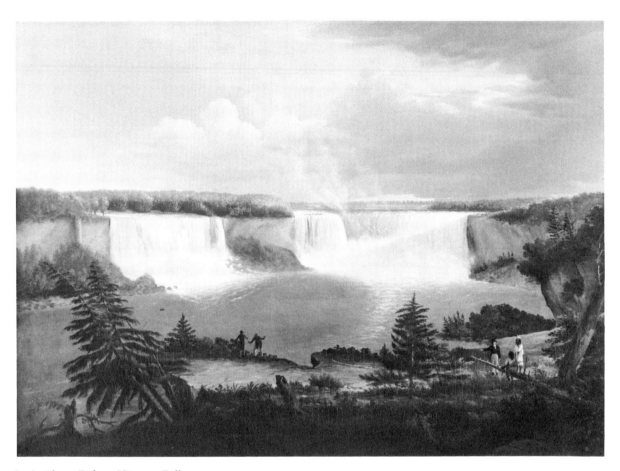

[57] Alvan Fisher. *Niagara Falls.* 1820.

Persuasion

As we have seen, when Francesco Milizia in 1781 spoke of a work of art as functioning like a self-contained machine, he prefaced this description by pointing out that before the machine can work there must be interest, there must be a bond between the work and the viewer. Although theorists and critics have held forth on all matter of technical and historical points, it is the nature of this bond that is basic to the character of what we call art. What is it about the painting that wins us to its point of view, and in what area of our minds does it operate?

Alvan Fisher saw Niagara Falls as a vast stretch of space subject to the discipline of the artist's sense of measure [57]. The potential wildness of the scene is held in check by this skillful harmonizing of every part. The painting forms a kind of contract between man and his environment. Man knows his place as dominator of his view and maintains it with ease, yet recognizes the magnificence of the space in which he dwells.

Some seventy years later, George Inness painted a view of Niagara that is so different one might wonder if the Falls itself had changed [58]. Of course it had, to an extent, as had the environment around it, but physical changes hardly explain the difference. Where is the clear measure and perfectly maintained distance of Alvan Fisher's view? Where are we, in fact, in relation to the Falls?

The question of "where" is important. At first thought, "where" might seem a quality subjectable to simple measure. Fisher thought so, and even made diagrams to indicate from what points he drew the Falls. But in matters of perception, the "where" is rather more complicated. Inness's painting might be accepted as a hazy view in dark and cloudy weather, an "impression" of the Falls when details are obscured. One might go so far as to trace the atmospheric situation that would provide such a view. By clearing up the haze, in other words, we could

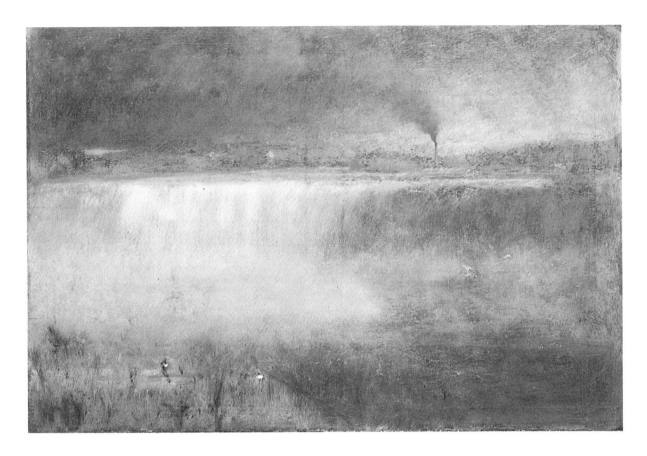

[58] George Inness. *Niagara.* 1889.

come to an agreement about our own position and that of the
Falls. But something happens with this particular haze that is
harder to explain. It takes a very active part on its own as it
rolls in and out, revealing an object here and a ray of light there.
In fact, we begin and end with the haze, the softly undulating
colors, rather than with the Falls. The subtly graded colors,
sensuous yet lacking in substance, that we accept as atmospheric
haze, effectively set a state of mind—ruminative, alert to remem-
brance—in which the specific aspects of natural phenomena in-
trude to tie the rumination to the natural world. It is irrelevant
to talk of where we stand; the "where" has rather to do with
the level of consciousness on which we accept the provocative
scene.

Inness had not always painted in this way. When he painted

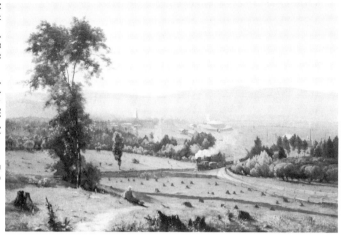

[59] George Inness. *The Lackawanna Valley.* 1855.

The Lackawanna Valley in 1855 [59], he obviously accepted the act of looking candidly at nature as an adequate means for treating what was in front of him. The view of the valley with its puffing railroad train is not harmonized in the manner of Fisher's *Niagara.* Inness felt no need to make the nature he saw act out a particular pattern. The great spread of land, the flood of light bestowing its preference here and there, were quite enough to content his view. There is no reason for us, as spectators, to demand more; the fresh presentation of things as seen hardly opens the doors to speculation.

On the other hand, *September Afternoon* [60] painted two years before *Niagara,* although lacking the mists and the lowering sky of the Falls, carries with it the suggestion that there is more than meets the eye. The strange soft forms and richly pitched colors evoke more than simply recollections of what autumn foliage looks like.

By blurring our sense of the finite, our pragmatic belief that all can be held up to rule, Inness awakens the possibility of a freely speculative use of the mind. Yet in these late works, not just any speculation results. Through his muted colors and intangible forms, Inness creates a mood accepting of mystery. As we contemplate the effect of flux and change that we associate with

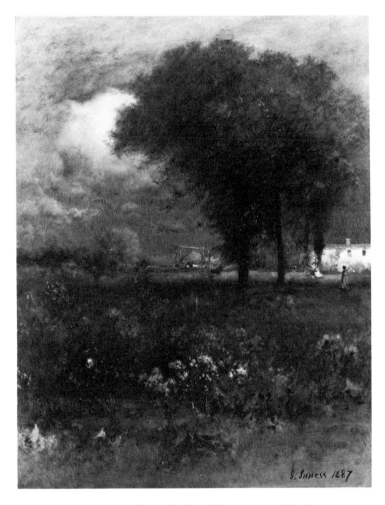

[60] George Inness. *September Afternoon.* 1887.

nature, we are moved to think of the view as having some special meaning. Exactly what meaning is not the question. The promise of meaning can be as much of an aesthetic attraction as Greenough's famous "promise of function." What is important is that the mind is alerted to a quest, a pursuit. These paintings *pose* questions, they do not answer them.

Inness found encouragement for his views of nature in the teachings of Emmanuel Swedenborg, the eighteenth-century Swedish mystic who found an exact equation between physical growth and moral growth, seeing the natural world simply as a material manifestation of the spiritual world, a relationship he

described in his theory of "correspondence." One could learn to "see" the spiritual world in one's surroundings. But such vision was not reserved for the followers of Swedenborg. There seemed a particular will in the 1870s and the 1880s on the part of many to reestablish an emotional or spiritual bond between the individual man and the larger environment.

The shadowy woods and luminous skies of Ralph Blakelock's strange pictures [61] are less traceable to specific places than are the landscapes of Inness—specific geographical locations, that is. There is little doubt that the woods which shelter *Nature's Mirror* is discoverable only in the reaches of the mind. Objects materialize out of the dark scumbled paint, but threaten at any moment to retire again into the shadows. They have no existence of their own but, like creatures in a dream, have their being only in the context of remembrance. We accept this because with his silhouetted trees against blue-green skies and his unfathomable shadows and inexplicable lights, Blakelock has persuaded us to enter his mood—a mood in which nature exists only in the mirror of the mind, as a part of our thought and feeling.

[61] Ralph Albert Blakelock. *At Nature's Mirror.* Undated.

[62] Ralph Albert Blakelock. *Moonlight, Indian Encampment*. Ca. 1885–1889.

Blakelock's is a strange world, both inviting and alien [62]. His moonlit skies are cold and his lacy trees betray unexpected anxiety. Yet his shadowy forest interiors promise protection, a shielding from the outside world. The mood is sweet with melancholy.

In works such as these, the place of the artist has changed markedly from that of a man who faithfully records the nature he looks at; he has become a maker, a man who creates a world that only by reflection relates to the ordinary things around us. The work of art, following the promptings of the artist's own creative spirit, produces an environment of its own. The idea of artist as creator—rather than imitator—was not new, but coming immediately after a moment in history when nature was the ultimate art and the artist was only nature's helper, it seemed quite revolutionary. At the center of the inevitable controversy, quite by his own choosing, was the expatriate American painter James McNeill Whistler. Of course, he drew his inspiration from nature; but when he began a picture, such as his *Valparaiso Harbor* [63], a shape or a color and its placement depended on

[63] facing: James Abbott McNeill Whistler. *Valparaiso Harbor*. Undated.

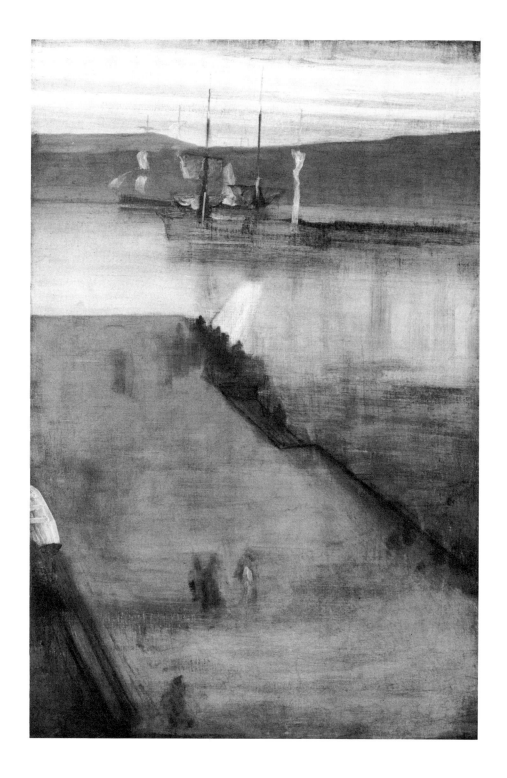

the part it would play in the total effect of the painting, not on how much it resembled the object to which it is related. To be sure, there is a sense of space, but it is not the kind that seems only a fragment of a larger space that extends beyond the confines of the picture, inviting us to move from this segment into a wider landscape. In a way, the picture does seem to be a fragment, but it is within the fragment itself that interest develops. The bare simple planes, abruptly chopped off and not clearly defined, work together like a large mosaic. The series of horizontal shapes is cut through, rather arbitrarily, by a broad diagonal space, dividing the picture plane in so unconventional a fashion as to fix the attention. There is an unresolved question as to whether we see the space as two-dimensional or three-dimensional. In color, the painting at once strikes its own key; it is a color that is only remembered from nature. All variations seem basically nuances of the dominant soft blue tone, yet they contrast enough to set up an interplay of their own. Similar colors call attention to each other here and there, and the wispy figures in the foreground echo the larger harmony in an almost imperceptible voice. All is so silent and so far from touch.

Whistler later gave his paintings titles such as "nocturnes" or "studies," likening them to musical works, because that is how he wished them to function: as composed harmonies playing directly on the mind the way he thought of music as doing. He was supported in his point of view by what he learned of Chinese and Japanese art [64]. Clearly, the Japanese prints and Chinese paintings—so different from works in the illusionistic tradition of the West—were quite frankly the creation of the artist. And art, for Whistler, was always creation, not imitation.

Although Whistler sets out to involve us through his subtle harmonies of color and form, he has little chance of success unless we are prepared to accept the experience of art as something special, not to be encountered elsewhere—except, of course, when we see nature imitating art. The Thames began to look like a Whistler painting after Whistler painted it, and Provence began looking like a Cézanne. By accepting art as art,

[64] Hiroshige. "The Japan Embankment in the Yosiwara District."

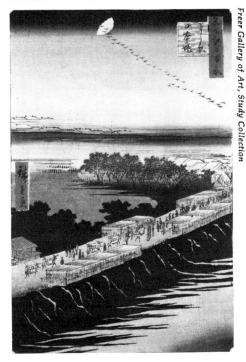

a whole new range of happenings and realizations becomes possible, obeying the special dictates of the mind rather than the fixed external laws of time and space. Furthermore, in this world of art, the works of all times and all places live together. The images amassed by a connoisseur become like a museum of the mind. It was just at this time, also in the 1870s, that many art museums were founded in the United States, hoping to bring together collections from all periods and places, making the connoisseur's mind a public place. Far from belonging to everybody's view of nature, art now belonged to culture and culture depended on the "best that has been said and thought in the world"—in Matthew Arnold's apt phrase. It required both knowledge and a highly refined taste. Subtlety of expression, the nuance, was the most potent means, the slight hint spurring the mind to reflective action and not limiting its course.

John La Farge's meticulously painted wreath hanging alone on an old wall into which a Greek inscription has been scratched, might be mistaken by a casual observer as just a nicely painted wreath of flowers [65]. For those prepared to look at this painting with John La Farge, it is the source of much pleasurable rumination. The Greek inscription, whether one reads Greek or not, immediately evokes an environment woven out of all one's associations with Greek literature, art, and that idyllic existence which the modern world has accepted as the life of ancient Greece. The fresh flowers against the ancient wall suggest newness and tradition, youth and age. But the wreath is not all bright flowers; the side in the shadow seems sparse and a little melancholy, punctuated only with a single poppy. There is a note of poignancy with the pleasure, emphasized also by the isolation of the wreath on the stark white wall. The inscription reads, by the way, "As summer was just beginning." The title of the picture is *The Greek Love Token*. As the wall might say, "And summer will pass."

This is not an antiquarian picture telling us something about Greece; it uses all of its power of reference to tell us something about ourselves. If we can judge from his painting *The Golden*

[65] John La Farge. *Greek Love Token.* 1866.

Age [66], John La Farge's concept of the idyllic world was one
in which the senses were alert to the most subtle pleasures, the
perfume of flowers, the delicate turn of a leaf, the soft touch
of flesh. It is a world of unsullied youth in which each experience
is approached as new, with innocent wonder. But the sensory
pleasures seem suspended in the memory where they retain their
freshness and become more vivid with the years. An alternate
title for the painting is *Eve*.

Probably more than any other American painter, La Farge was
responsible for launching this tendency of cultivated lyricism
which would last beyond the end of the century. Wyatt Eaton's

[66] John La Farge. *The Golden Age.*
1870.

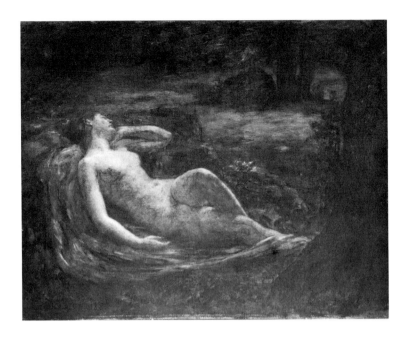

[67] Wyatt Eaton. *Ariadne*. 1888.

study of *Ariadne* [67], almost twenty years later than *The
Golden Age*, seems to live in a similar world of sensuous detach-
ment. It was a likeness of Ariadne [68], painted by John Van-
derlyn, that created one of the early scandals in American art.
In 1819, the public was not willing to grant the realm of art any
privileges not consistent with society at large; Ariadne was not
a nude heroine of ancient line, but a naked woman shamefully
displayed. Easton's Ariadne, more sensuous in some ways than
Vanderlyn's, lies sleeping in a dream of art, secure in this con-
text from the vulgar world. A fleshly creature, she nonetheless
embodies all the other Ariadnes who have expressed the fan-
tasies of artists. And she floats serenely in a world of recollection,
in the private museum of dreams.

The artist's purpose in society, according to artists of this per-
suasion, was to maintain contact with the current of high human
expression through the ages, and to translate this elevated ex-
perience for his own time. It was not a matter of art matching
the taste of the public; it was the public's obligation to rise to
the level of art. Taste, which had often been thought of as
indisputable, had to be developed, Charles Eastlake pointed out

[68] facing, top: John Vanderlyn.
Ariadne. 1812. Engraving by Asher B.
Durand.

[69] facing, bottom: Thomas W.
Dewing. *Summer*. Ca. 1890.

78

in his much read *Hints on Household Taste* of 1868. It must be refined by a careful disciplining of the senses so that the nicest degrees of difference can be appreciated. One should learn to live the aesthetic experience, not reserve it for an occasional trip to a gallery.

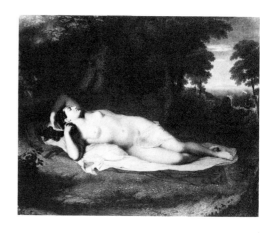

Taken literally, the apparent subject matter of Thomas Dewing's painting, *Summer*, seems ridiculous: two elegantly gowned women fishing in a greenish fog [69]. Yet in spite of the particularity of the dress and the individuality of the women, an air of fantasy envelopes the scene, allowing it to hover between the world of high fashion and a fragile, abstract environment of

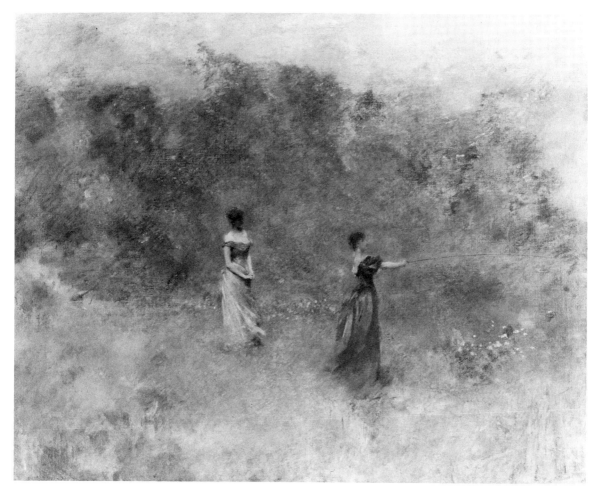

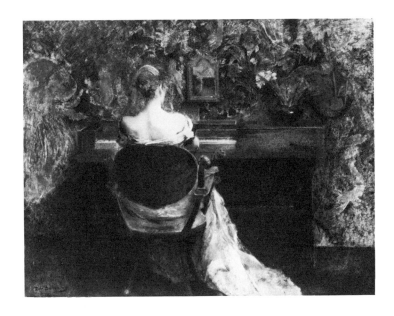

[70] Thomas W. Dewing. *The Spinet.*
1902.

refined sensuousness. No, it was not fashionable for refined
ladies to carry on in this manner in 1890; these figures embody
an ideal of taste, detached from the vulgar pressures of urban,
mercantile life, afloat in the unattainable mist of perpetual sum-
mer. There is no earth, no sky, no thought of time, only this
enduring moment of unadulerated pleasure. One might rant
against the irresponsibility of the leisure class in the face of
grave social problems, but Dewing was insisting that art belongs
to the leisure of the mind, not to mundane affairs.

In this view, the visual arts, music, and poetry were all one.
While earlier artists often leaned on narrative as their means,
Whistler, La Farge, and Dewing identified themselves with the
poets, poets who emphasize imagery and evocative sound rather
than plot. Like Mallarmé or Verlaine, the painters found sug-
gestion more potent than statement. In music, they preferred the
tinkle of an antique instrument [70] to the rousing choruses of
a military band. The spinet could summon recollections of things
past to mingle with the sensuous pleasures of the present. Many
felt this was the spirit of a new Renaissance, this new conscious-
ness and refinement of all man's intellectual faculties. The great
Columbian Exposition of 1893, with its gleaming, intricately

[71] facing: Abbott H. Thayer.
Virgin Enthroned. 1891.

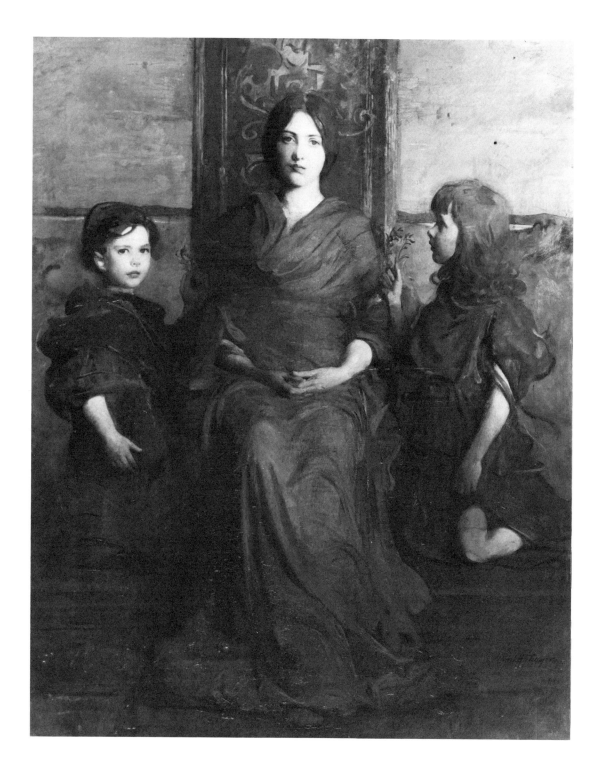

designed white buildings assembling a repertory of past styles, its lagoons and Venetian gondoliers, was a popularization of this concept which had a profound effect on the place of art in America.

So persuasive was this image of art, that it is difficult to distinguish at times between individual likeness and abstract idea. Does Abbott Thayer's *Virgin Enthroned* of 1891 [71] represent the Virgin of Christianity, virginity in general, or simply a modern young woman? The obvious answer is that it is all of these. Like his fellows and predecessors, Thayer worked directly from nature, aware of all the complex beauties of light and color around him, yet he had always in mind the traditions of art. Trained on classical models and well schooled in the arts of the past, especially Italian art of the fifteenth and early sixteenth century, Thayer brought his colors down to a museum hush almost without being conscious of it and saw his models as if already existing in a Florentine frame. It was a time of allegory, in which the perceived fact, without losing identity as a perceived fact, had also an existence on another plane of signification.

Once artists and theorists alike agreed that art had persuasive power of its own, whether through the suggestive play of perception as in Inness and Blakelock or the cultural evocation and aesthetic subtlety of Dewing or Thayer, they became more and more concerned with how one responds to a work of art, not how one responds to nature. As Whistler, for one, had made clear, colors and forms and their relationships have consequence for the perceiving mind. But they work in different ways. For example, the small detail of drapery [72] from a painting by Elihu Vedder seems to have a life all its own; it twists and turns, neither rising nor falling in space. To say that a line in a painting twists and turns is, of course, a highly figurative statement. It does nothing of the sort. It is we who twist and turn looking at it. That we tend psychologically to "follow" a line is no great revelation, but it is worth considering for a moment the paths in which lines might lead us. These lines, which we looked at

[72] Detail of drapery from Elihu Vedder's *The Cup of Death.* 1885 and 1911.

once before, taken from a drawing book published in the 1840s, have direction:

They are comforting motions in their way, because they cause no uncertainty. We can predict their beginning and ending points and reproduce them with ease because, not only do we follow them, we understand the principle of their construction. They are all arcs of circles, regular parts of recognizably regular shapes, and insofar as they belong to this external system, we can view them with little commitment. But these lines:

They are an unruly lot, because each seems to have its own sense

of direction produced by its own animation. Looking at them we can take nothing for granted, nor can we relate them to a system outside. We cannot, in other words, extricate ourselves from their coursing vitality. These are the kinds of lines that Vedder used to construct his entire picture [73]. Most of the lines pull and drag in a languorous way, and we can sense their weight and slowness, as if our breathing were affected by their rhythm.

Beginning during these same years, the 1870s and '80s, some theorists also became interested in this capacity of some forms to take on an animal vitality, demanding a continuous participation on the part of the viewer so that the viewer and the thing observed, sharing the same vitality, for the moment are as one. Theodore Lipps called this *Einfühlung*, which became in English "empathy." The forms need not belong to an animate object. Louis Tiffany's hand mirror [74] has the vitality of a living creature without looking like any actual being at all. This was by no means a new phenomenon in art—for example, see Thomas Cole's tree from 1831–1832—but it was returning to importance at the moment when a new consciousness of the emotional response to sensuous experience had developed, and it became a profound and powerful persuader.

In no works is this more true than in those of Albert Pinkham Ryder [75]. Jonah struggles, in one of Ryder's finest paintings, against most extraordinary waves which push and thrash with astonishing might. Their rhythms are so engulfing that it is not Jonah we worry about, but ourselves. Reduced to a few angular forms at the bottom of the canvas, Jonah can be seen only in terms of the thundering rhythms that beat him down. The whale, looming at the right, is only a confirmation of the terror. Above, floating in somewhat easier rhythms, is God the Father, not seeming at all out of place in this spiritual turbulence. Interestingly, the identification of specific objects—Jonah, the boat, the whale, and God the Father—comes during or possibly after we experience the excitement of the churning forms; the vitality of the forms carries the main burden of meaning.

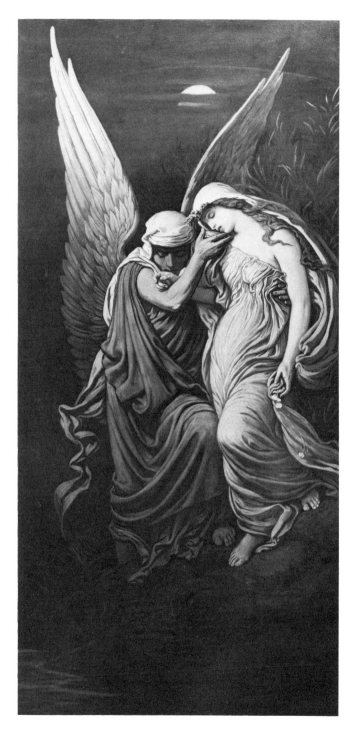

[74] Louis C. Tiffany. Hand mirror
in the form of a peacock. Ca. 1900.
*Collection, The Museum of Modern Art, New York;
gift of Joseph H. Heil*

[73] Elihu Vedder. *The Cup of Death.*
1885 and 1911.

There is poignancy in the wispy, useless sail in Ryder's *Moonlight* [76] which is attracted to the moon, but flaps vainly in space. The strange, off center, tipping relationship among the forms of boat, sail, and the waif-like clouds, all magnetized by the moon, creates a tension that is hard to escape. We take the part of the boat, the sail, and each cloud in turn, sharing their loneliness as they are caught suspended in a poetic silence.

In this little essay, we have explored, in general, three ways in which artists have been concerned with collapsing the distance

[75] Albert Pinkham Ryder. *Jonah.* Ca. 1885.

that might exist between a work of art and the mind of the viewer or, for that matter, ways in which the artist could identify himself with his work: Through the evocation of an enveloping mood by which nature was transformed; through immersion in an historical nostalgia in which all past and present time was merged; through a total identification with the line, the form, the actual substance of his work. But basic to all is the fact that the artists were persuaded that in art the external and the internal are one, that the duality of subjective and objective has little meaning.

[76] Albert Pinkham Ryder. *Moonlight.* 1880–1885.

If you wish to pursue these ideas further—

Many artists in the late nineteenth century were interested in persuasiveness, including the composer Richard Wagner (1813–1883) whose writings and music were often referred to in this regard. An early statement of formal expressiveness was Edgar Allen Poe's "The Philosophy of Composition" (1846). J. A. M. Whistler argued well for the autonomy of the artist in dealing with nature in his essay *Mr. Whistler's Ten O'Clock* (1885). The concept of "empathy" was elaborated by the philosopher Theodor Lipps, summarized in his *Zur Einfühlung* (1913). Vernon Lee (Violet Paget) early discussed Lipp's theory in English in her *The Beautiful* (1913). The critical problem arising from works that demand so personal a response was well articulated by Konrad Fiedler, *On Judging Works of Visual Art* (1876). The idea of art as continuous experience in time has a philosophical complement in Henri Bergson's *Time and Free Will* (1889). On the nature of the artistic experience as such, George Santayana's *The Sense of Beauty* (1896) and Benedetto Croce's *Aesthetic* (1901) present a view contemporary with some of the works.

The Pure and the Impure

In talking about art of the twentieth century, *abstraction* is a word that is regularly stumbled over. It turns up in all sorts of unexplainable contexts: in opposition to *realistic* or *figurative*; as the ultimate goal in an historical sequence that leads from less to more abstract—in this context, there is even that odd formulation *semi-abstract*; and sometimes it is used as a thoughtless synonym for *modern*, standing symbolically for all modern art. Probably the difficulty got started at the beginning of the century when artists and supporting critics, such as Clive Bell, waged a campaign to awaken the public to the fact that form, not likeness, carried the major content in a work of art. From such a premise, it was easy to argue that a work of art gained in power to the degree that it disentangled itself from subject matter altogether. The most effective work, it then might be assumed, would be one with no subject matter at all. By 1912 several artists had reached this stage in their work and theory, although they had proceeded from quite different points of departure.

Tidy and logical as this supposedly historical evolution toward abstraction might seem, nicely organized around so broadly applicable a term, it by no means states the whole case. Nor does it take into account the true nature of problems regarding form and our reaction to it that are posed by much of the art created over the past seventy-five years. If you look at two paintings such as Joseph Albers's *Homage to the Square* [77] and Adolf Gottlieb's *Three Discs* [78], for example, it is evident that they have nothing in common other than the fact that neither depicts an object; the experiences that the two paintings provide are profoundly different. The term *abstraction* applied to these works would not take us very far in indicating what is so distinctive about each of them and how fundamental their differences are.

In normal usage, the word presents no problems: "in the abstract" means to consider something in general, without a

[77] Joseph Albers. *Homage to the Square, Insert.* 1959.

[78] Adolph Gottlieb. *Three Discs.* 1960.

specified particular application. Similarly, an abstract noun—like beauty or goodness—is one that stands for a quality as such, quite outside of a specific context. There is an advantage in this kind of abstraction: it allows us to withdraw for a moment from the distractions of particular instances—the beautiful girl, the violent act—to consider and appraise the nature of the quality itself—beauty, violence. In the visual arts, however, the word usually takes a different turn, more akin in its application to that used by lawyers when they speak of an abstract of a case. Early in the century, most critics and the public assumed—because of

the immediate background of nineteenth-century art—that all art begins with something seen, with a concrete object. As the new theories took shape, it was allowed that the artist might "abstract" from the object or from the experience of looking at it whatever aspects he wanted. Abstraction, thus, was often spoken of as the deliberate distillation of some selected aspects of the seen world. One could therefore talk of degrees of abstraction— how close or how far the artist's image was from the particularities of the object—as if that in itself was a matter of aesthetic significance.

It is too bad that critics perpetuated this idea that abstraction was a strategy of means rather than retaining the common understanding of abstraction as a category of mind. In fact, from at least 1912, some artists preferred to remain close to the more general meaning of the term. They were concerned only in a most general way with experiences that could apply to the perceptions of the world at large. Instead of presenting a view of nature, they set out to provoke directly through forms and colors a state of mind unequivocally removed from the complexities of everyday sense and memory. In a way, they created visual lessons in order. Although a part of the perceptual world, their works spoke to the mind not in terms of things, but in terms of motions, balances, and a sense of perfection. Their kind of abstraction might be thought of as existing on a par with what we know as abstraction in language, although the range of their abstract concerns was consciously limited.

Of course, to provide such a quality of mind the artist need not wholly dispense with all reference to objects. Benjamin West's *Helen Brought to Paris* [79], in spite of its amorous subject matter was, as we have seen, carefully calculated to remain on a detached plane of thought, building its special world out of the rhythms and harmonies that admitted no contact with the chance and irregularities of the rude material world. Even though he did not dream of a nonfigurative art, the theorist Quatremère de Quincy stated in 1823 that any work of art had clearly to separate itself from the appearance of nature first of all, other-

wise it could not be seen as a pattern of thought, an object of the mind. In other words, perfection might make reference to the world of things, but it had to be understood as *perfection*, not a perfect something.

The sense of perfection in Joseph Albers's painting is not to be missed [80]. In the first place, the elements from which it is constructed are unambiguous and clear. The square, which is its theme, is probably the most regular and comprehensible form there is. And this is not a square something; it is a square. The clear but exceedingly subtle color relationships are much too finely determined to suggest in any way that they are the product of chance. The very deliberateness of the work, its seeming measurability, provides a feeling of reassurance. Yet, although everything seems quite explainable, an activity is going on that one would not expect to find generated by such simple means.

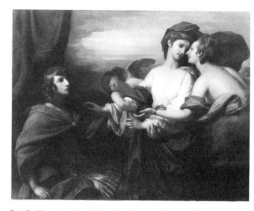

[79] Benjamin West. *Helen Brought to Paris.* 1776.

[80] Joseph Albers. *Homage to the Square, Insert.* 1959.

93

A quiet argument is taking place over a matter of "whereness"— the relative location in space of the superimposed squares.

When two colors are placed next to each other, one tends usually to make a stronger demand on our attention because of its relative quantity, intensity, or assembly of qualities. Thus, it seems to come toward us, with the result that its neighbor appears to recede. This indeed takes place in the Albers, but the adjustment is so fine that it is difficult to determine at any one moment which color is coming forward and which is going back. A special sort of movement is taking place that has no goal in terms of measured space or distance. It is most easily describable simply as an active experience of the eye as it deals with motion and space. Then, there is the character of the color. In this painting, it is light and sunny, inviting us to engage in this delicately equalized tug-of-war as if we were participating not with substance, but with light itself. There is no goal to pursue in the painting, no problem to solve. Its meaning lies precisely in this pleasurable involvement which is at once intense and quieting to the mind. All other activity of memory or thought seems to be suspended during this moment of abstract concentration.

Although no less concerned for art as distinct from the appearance of nature, other artists have looked upon structure as having a totally different function. They have used all of the sensuous means at their command—color, shape, texture, line— to create an experience that is so inextricably entangled in the whole range of our on-going activities that we cannot isolate it, even if as a picture it looks like nothing we have ever seen before. Rather than allowing us to withdraw for a moment to think or judge, such works propel us into intensified acting, remembering, and sometimes dreaming. It would be hard to call such a state of mind abstract.

It is in this sense that looking at the painting by Gottlieb [81] proves quite different from looking at the work by Albers. Not only does the painting seem to have been produced rapidly and to have taken advantage of chance strokes of the brush and the

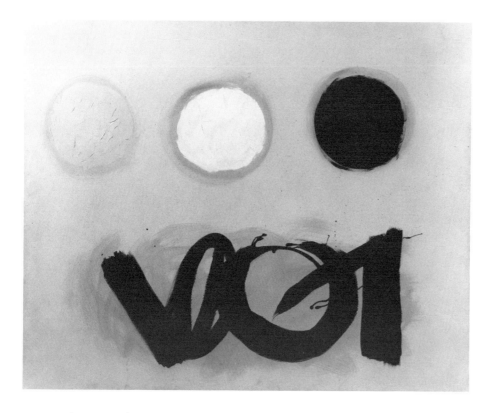

[81] Adolph Gottlieb. *Three Discs.* 1960.

wayward nature of paint, it engages our attention in a similarly spontaneous way, encouraging us to look at it in an open, spirited, and casual frame of mind. We join with the artist in the seemingly impetuous activity of gesturing with the brush to create forms that swing in a determined rhythm, carrying empathy that made the forms of Ryder a part of our living, breathing bodily system. Even the circles that float happily above the bold black strokes have a buoyancy of their own. They are, one has to admit, not really circles, but forms in the process of becoming circles. Geometry was not their point of departure, but their unrealized goal. The fact that they never become simply circles is important. Their liveness depends on a continuous promise, on their living in a state of process. In fact, the whole painting engages us in a process of becoming. It calls attention to and celebrates an underlying sense of vitality that suddenly seems to activate both ourselves and the world around us.

What happens to a circle when it does not quite succeed in being a circle? We ask few questions of a perfect circle. We neither go around it or through it, but accept it as the completed form it is—the formula for which we once memorized in school. In other words, we move very quickly from the sensory information that we read as *circle* to the concept of circle, paying slight attention to any vagaries that might occur in the sensory perception. In fact, if it does not exactly match the perfection demanded by the formula, we are willing to accept it as merely a badly drawn circle—a circle crying to be liberated from the tyranny of a shaky hand. But there is a point beyond which the mind is not so quick to proclaim the form a circle. The formula does not at once come to mind, but instead we follow the contours and puzzle at the expanding and shrinking shape. "It looks like a pear," you might say, "or a pumpkin," and with this a whole associative area of the mind begins to open up. From a closed form, in every sense, the circle has been transformed into a wide-open experience of suggestion and memory.

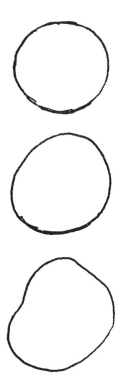

Isamu Noguchi's marble sculpture called *Grey Sun* [82], although it suggests a simple circle, is continuously varied until what might have been a fixed and static object becomes a strange and magical form.

During the 1950s, certain forms created by Noguchi became very popular in the decorative arts, especially in tables based on one he had designed himself [83]. The shape was popularly known as a "free form." Why free? Possibly because such a form seems to grow from a free play of the mind in defiance of any formula and invites the viewer to join freely its curiously organic activity without worrying about proportion, balance, or order. Gottlieb's circles do not go this far in attracting attention to themselves. They are more or less noncommittal shapes that bounce in space to the rhythm of the line below. Yet they are in no sense impassive to the suggestive vitality that pervades the canvas and keeps us identified with the experience at hand.

Early in the century, artists and critics began to talk about "pure

[82] facing: Isamu Noguchi. *Grey Sun.* 1967.

[83] Isamu Noguchi. "Free Form"
table. 1944.

form." Originally, it simply meant form as distinct from subject matter—distinct from "thingness." By the 1920s pure form had come to mean form to which no associative qualities could be attached and which left the attention free to concentrate wholly on the interplay of the forms themselves. Thus, a kind of exemplary world could be created, surprising and new in its variety of relationships and tense balances, but one in which nothing was left to chance. The de Stijl artists in Holland, who began to publish their influential magazine in 1916 [84], even declared that they preferred synthetic materials to natural, because then even the fabric itself was a known and controllable element. A symbol of a pure and rational universe, this art often took on philosophical and religious overtones. Mondrian talked about his "pure plastic art" in terms of moral qualities and universal spiritual harmony, as did Malevich in expressing his goals for "suprematism." Not unlike the principles underlying Pestolozzi's educational system, their premise was that the eye could teach the mind to function in a harmonious way.

It was only a step from painting a symbolic universe to the creation of actual spaces for living, and by the 1920s the idea of a dynamic spatial environment, purged of all sentimental asso-ciation, was extended broadly to architecture [85]. Le Corbusier dreamed of an ideal city [86] in which man would live in a wholly rational visual environment that would stimulate his intellectual faculties by the refinement and subordination of sense. Different from the ideal cities of late-eighteenth-century planners such as Ledoux [87] and Boullé, these surroundings

[84] Cover design of the journal
DE STIJL. April 1918.

[85] Le Corbusier. Villa at Garches. 1927.

[86] Le Corbusier. Design for a modern city. 1922.

[87] Claude-Nicolas Ledoux. Perspective rendering of the city plan of Chaux. Ca. 1774.

would not be based on recognizable symmetry, but on an order that would be revealed only through the perceived stresses and balances of the simple forms. The environment would thus remain visually alive. Harmony would be the product of active perception, yet perception would be always in union with intellectual order.

If there is such a thing as *pure form*, in the sense in which we have been speaking, then one must suppose that there exists also *impure form*. What would an impure form be? Exactly that sort we earlier discussed that refuses to let the imagination alone and sweeps us along with the power of memory, sensory richness, and what seems to be actual physical participation. In other words, those forms are hardly pure which plunge us actively and consciously into the whole uncontrollable complex of the mind and the sensuous environment from which the pure forms would free us.

In 1907 the young German philosopher and historian Wilhelm Worringer published a fascinating treatise—widely read by artists over the next few years—in which he recognized that extraordinary, persuasive power of form that had been called *empathy*, but pointed out that there was an equally attractive, although opposite, quality of form. He called it *abstraction*. In looking at the past, he found that some cultures created visual systems which, through their geometric certainty, served as psychological protection against what seemed to be an uncontrollable environment and an uncertain fate. This was dependence on the abstract. Others, he noted, accepted freely the flux and flow of their environment and were content to make themselves a part of it, courting exactly the surprise and mystery that the others abhorred. Theirs was an art of empathy. What he called a will to abstraction, we might identify in a way with our will to pure form. His interpretation of empathy would admit of our "impurity." Regardless of what we might now think of Worringer's application of these modalities to the interpretation of past cultures, it does seem clear that the two attitudes toward form spring from different needs and are not to be confused with one another. This does not mean that one person cannot respond

[88] Adolph Gottlieb. *Three Discs.* 1960.

with equal enthusiasm to the paintings of both Albers and Gottlieb [88]. But the experiences afforded by the paintings dwell in quite different realms of the mind and cannot even be described effectively by the same language. The paintings satisfy quite different human demands.

In considering narrative as a procedure in the visual arts, we found that an informative exercise was to note what catches the eye and then, on continual looking, what holds the mind. Such a procedure might prove useful here. Not that some works require little time while others demand more; it is simply that what happens in the time we spend with the works may differ markedly in character. For example, Theodore Roszak's *Construction in White* [89] of 1937 is a pristine organization of opaque and transparent planes which intersect one another at precisely set right angles. Yet in spite of the regularity of the forms and the clarity of the organization, they create all manner of intricately related areas of light and shadow that are as transitory as the light that illuminates them. The promise of endless complexity is stabilized, however, by the persistence of the single principle of order so that, no matter how complex it may be, we never lose the key to the system. An object of delight in its own right, the sculpture is as detached from the creating hand of the

[89] Theodore Roszak. *Construction in White*. 1937.

artist as it is from our own bodily consciousness. Touch and gesture are not part of the experience. Our time is spent in a mind-clearing pursuit of expected and fulfilled visual pleasures.

By contrast, in *The Defender* [90] which Seymour Lipton created many years later, even the basic principle of organization is

difficult to define. Forms fold in upon themselves leading into shaded interior areas which cannot be entirely penetrated, while others protrude in harsh shapes that seem to be the vestiges of some totemic figure. The scroll-like shapes are not geometrically regular, and the uneven mottled surface confuses any effort at definition. The longer we look, the stranger and more mysterious

[90] Seymour Lipton. *The Defender*. 1962.

Lent by Marlborough-Gerson Gallery, New York

[91] facing: Willem de Kooning. *Woman VIII.* 1961.

[92] Detail.

the object becomes, as if it belonged to a cult with which we feel
sympathy but cannot, within the reach of rationality or historical
knowledge, understand. In looking at the brooding form, how-
ever, we have joined with someone, somewhere, in a special
aura of feeling; the object does not stand alone.

The feelings provoked by Willem de Kooning's violently slashing
painting, *Woman* [91], may pose an equally insoluble problem for
the understanding, but it certainly leads to no generalized sense
of community. The act of creation is boldly recorded in the
gesture of the artist and with equal boldness reenacted by the
viewer. A compulsive drive in the strokes suggests an urgency
that has no patience with abstract detachment or undisturbed
contemplation. There is, moreover, something naggingly per-
sonal in the response it provokes. In spite of any belief we might
have in pure plastic values, the pushing forms translate them-
selves into body, flesh, and being [92].

The three works by Roszak, Lipton, and de Kooning have led us in three quite distinct directions on continuous viewing. In a sense, we know right from the beginning in looking at *Construction in White* that, for all its complexity, we are exploring within established bounds. It holds us agreeably within itself. The Lipton, on the other hand, lures our imagination into an undefined quest for identification and meaning. No less continuous, but demandingly personal, is de Kooning's *Woman* which opens up an undefined range of experience we urgently feel the need to express.

Somewhere toward the end of the past century, the word *expressive* began to work its way into the vocabulary of art. It was best explained by the German critic Konrad Fiedler in the 1870s who spoke of the work of art as being the product of a "will to art" that the artist sensed deep within himself. According to Fiedler, there was no external set of standards for judging art; a work was successful when it fulfilled the artistic urge that prompted it. But the viewer then, with no rules to fall back on, is faced with the problem of discovering the relationship between the creative impulse and the visual expression. The best the viewer or critic can do, said Fiedler, is to try to understand within himself an urge equivalent to that which prompted the creation and which the work fulfills. In a way, the artist begins with a question, with a prompting within himself, and creates the work as an answer; the viewer begins with the answer and must search out within himself the significant question. There is no simple or final solution. The pursuit of meaning within the artistic experience is a continuing quest.

Much of our *impure* art does seem to follow the pattern Fiedler suggests, sending the viewer scurrying into himself to take soundings of his reactions. For the timid, there are countless books to explain why—psychologically, sociologically, physiologically—the artist did what he did, thus providing a properly safe distance between the viewer and the experience. The fact remains, however, that no amount of external research will supply the real motivation of the artist. The complex nature of

the human expression can be understood ultimately only in terms of our own inner sensibilities. In criticizing a work of art, all we can be sure of are our own interior proddings of the meaning that the work holds.

Much that we like to call expressive—or expressionistic—art, then, is not so much an art in which the artist has expressed himself as an art that makes us feel that we have found expression for something deeply rooted within ourselves. In the work of art, we share that consciousness with another. In this sense, de Kooning's work is expressive. We assume it to be the result of a deep urge to express, and we harbor the feeling it provokes to make the expression our own.

Often works we call expressive have the look of chance, although we know that they are always in one way or another the product of the artist's deliberate doing. This has special appeal, because we tend to believe that the unrehearsed gesture is always the most revealing. Besides, the obviously unprogrammed form can hold special interest for the mind which is free to do with it what it wishes. From time to time, from Leonardo da Vinci to the present, artists and critics have found stimulating spurs to the imagination in accidental spots and shapes encountered by chance. One Italian critic, Vittorio Imbriani, in 1868 looked upon the combination of tones and colors that make up the unified form of a painting as such a single evocative spot and declared that it was precisely in such a spot, not in the subject matter, that the true content of a painting lies. Imbriani told how he once fell quite in love with the veining in a block of marble in which he found endless imaginative pleasure. Like the veining, the form of the work of art should, he said, stimulate the fantasy to the point of productivity.

The famous diagnostic tests of Dr. Rorschach, which he explained in his publication of 1921, have made the evocative qualities of ink blots famous [93]. His premise that certain ink blots symmetrically formed in a fold of paper could provoke involuntary associations that reveal an area of the mind not

[93] Hermann Rorschach. Test plate.

[94] Helen Frankenthaler. *Small's Paradise.* 1964.

reached by rational analysis was little different from that on which much art had for years been consciously based. But does the seemingly chance form of a work of art function only as a Rorschach test? Is Helen Frankenthaler's bright and lively painting *Small's Paradise* [94] just a monumental prodding into our untapped realm of free association? The shapes in the painting seem to have been created largely by chance, it is true, and they can hardly be looked at without some awareness of images that spring to mind. But the seeming chance in these ebullient forms has been guided at every step of the way by the artist's choice. Taking advantage of our capacity for free association and our enjoyment of the freedom it grants, Helen Frankenthaler has constructed a unified and individual work with which to engage. Unlike the little black spots of Dr. Rorschach's test, the painting sets the direction and to an extent the boundaries of an experience which is in itself pleasurable. The fact that it makes us aware of a strain of fantasy within ourselves is only one element in its pleasure, and we need not ask ourselves what the images it conjures up might mean.

In a way we have been talking about the pure and the impure from the very first discussion in this book. At least for the past two hundred years, it seems that art has regularly functioned in two quite opposite ways: to order the senses and bring the mind to a state of clarity and repose; or to arouse the senses and plunge the mind into an active, unending pursuit. Benjamin West's two paintings exist in totally different contexts, in different areas of our thinking, as do the views of Niagara by Alvan Fisher and George Inness. To spend one's time looking for structural order in the misty painting by Inness would be as out of place as talking of imaginative values in Fisher or looking for significant brush strokes in the work of Joseph Albers. Each work of art has its own place in the mind. The "where" in the consciousness is an essential part of the "what" in any work of art.

If you wish to pursue these ideas further—

Wilhelm Worringer's provocative little book, *Abstraction and Empathy* (1907) nicely sets forth the opposition between empathetic persuasion and aesthetic distance. Direct expressiveness in painting was advocated by Wassily Kandinsky in his *On The Spiritual in Art*, 1912. The sense of purity in art was well expressed in Le Corbusier (né Charles Edouard Jeanneret) and Amédée Ozenfant's essay "Purism" (1920) and in Piet Mondrian's *Plastic Art* and *Pure Plastic Art* (1937). Robert Herbert's anthology *Modern Artists on Art* (1964) contains several pertinent essays, including that by Le Corbusier and Ozenfant. *Theories of Modern Art* (1969), edited by Herschel Chipp, contains much material, including useful statements illuminating the idea of expressiveness in contemporary painting.

List of Illustrations

All dimensions are in inches unless otherwise specified; height precedes width and depth. Unless otherwise credited, illustrations are from the National Collection of Fine Arts, Smithsonian Institution.

[1] Benjamin West (1738–1820). *Self Portrait.* 1819. Oil on paperboard, 32¼ × 25⅝. Signed: B. West, Oct. 1819.

[2] Detail from Benjamin West (1738–1820). *Helen Brought to Paris.* 1776. Oil on canvas, 56¼ × 75¼. Signed: West 1776.

[3] Detail from Benjamin West's *Helen Brought to Paris.* 1776.

[4] Benjamin West (1738–1820). *Self Portrait.* 1819.

[5] John Hesselius (1728–1778). *Mrs. Richard Brown.* Ca. 1760. Oil on canvas, 30⅜ × 25¼.

[6] Thomas Sully (1783–1872). *Mary Abigail Willing Coale.* 1809. Oil on wood. 28⅞ × 24.

[7] Detail from Hiram Powers (1805–1873). *The Greek Slave.* First version, 1843. Marble, 44 × 14 × 13½. Signed: H. Powers Sculpt.

[8] Portrait diagrams.

[9] Plates from John Gadsby Chapman. *The American Drawing Book.* New York: J. S. Redfield, 1847.

[10] Upper, plate 1 from Thomas Pearce Dolbear's *A Chirographic Atlas of Twenty-four Plates to Accompany "The Science of Practical Penmanship."* New York: Collins, Keese and Co., 1836.
Lower, plate 12 from R. E. La Fetra's *R. E. La Fetra's System of Penmanship or Male Instructor, Designed for the Use of Writing Schools, Colleges, Academies, Common Schools, and Private Instruction.* Pekin, Ohio: 1852.

[11] Hiram Powers (1805–1873). *The Greek Slave*. First version, 1843. Marble, 44 × 14 × 13½. Signed: H. Powers Sculpt.

[12] Giuseppe Ceracchi (1751–1802). *George Washington*. 1795. Marble, 33 inches high. The Metropolitan Museum of Art, New York; bequest of John L. Cadwalader, 1914.

[13] Gilbert Stuart (1755–1828). *George Washington*. Undated. Oil on canvas, 30 × 25. United States Capitol, Washington, D. C.

[14] Rembrandt Peale (1778–1860). *George Washington*. 1795. Oil on canvas, 29¾ × 25¼. National Portrait Gallery, Smithsonian Institution.

[15] Horatio Greenough (1805–1852). *George Washington*. 1840. Marble, 136 × 102 × 82½. Signed: Washington by H. Greenough, 1840.

[16] Detail from a political cartoon about Woodrow Wilson by J.M.N. in Regina, Saskatchewan, *Leader*, published in *Cartoons* 2 (December 1912): 55.

[17] Detail from a political cartoon about Woodrow Wilson by Schilder in Indianapolis *Star*, published in *Cartoons* 2 (September 1912): 50.

[18] Alvan Fisher (1792–1863). *Niagara Falls*. 1820. Oil on canvas, 34¼ × 48⅛. Signed: A. Fisher pixt. 1820.

[19] Claude Lorrain (1600–1682). *Landscape with Merchants*. Ca. 1635. Oil on canvas, 38¼ × 56½. Inscribed: CLAVDIO. National Gallery of Art, Washington, D. C.; Kress Collection.

[20] Salvator Rosa (1615–1673). *The Finding of Moses*. 1662/1673. Oil on canvas, 48½ × 79¾. The Detroit Institute of Arts; gift of Mr. and Mrs. Edgar B. Whitcomb.

[21] Thomas Cole (1801–1848). *A Wild Scene*. 1831–1832. Oil on canvas, 50½ × 76. The Baltimore Museum of Art.

[22] Detail from Thomas Cole's *A Wild Scene*. 1831–1832.

[23] Thomas Cole (1801–1848). *Expulsion from the Garden of Eden*. 1827–1828. Oil on canvas, 39 × 54. Museum of Fine Arts, Boston; M. and M. Karolik Collection.

[24] Thomas Cole (1801–1848). *The Pilgrim of the Cross at the End of His Journey* (study for the series *The Cross and the World*). 1844–1845. Oil on canvas, 12 × 18.

[25] Jasper Cropsey (1823–1900). *Catskill Creek, Autumn.* 1850. Oil on canvas, 18¼ × 27¼.

[26] Detail from Jasper Cropsey's *Catskill Creek, Autumn.* 1850.

[27] Detail from William Trost Richards (1833–1905). *Trees Along the Stream in Fall.* 1861. Oil on canvas, 12⅝ × 20. Signed: Wm. T. Richards, 1861.

[28] William Trost Richards (1833–1905). *Trees Along the Stream in Fall.* 1861.

[29] Detail from plate 1 in J. Laporte's *A New Series of Laporte's Progressive Lessons in Landscape.* London: Griffith's Fancy Repository, 1816.

[30] Asher B. Durand (1796–1886). *Kindred Spirits.* 1849. Oil on canvas, 44 × 36. New York Public Library.

[31] Frederic Edwin Church (1826–1900). *Cotopaxi.* 1855. Oil on canvas, 28⅛ × 42⅛. Signed: F. Church 1855.

[32] Albert Bierstadt (1830–1902). *Mount Corcoran.* 1875–1878. Oil on canvas, 61 × 96¼. Signed: A Bierstadt. Corcoran Gallery of Art, Washington, D. C.

[33] Thomas Moran (1837–1926). *The Grand Canyon of the Yellowstone.* 1893–1901. Oil on canvas, 95 × 167. Signed: Moran 1893–1901.

[34] William Trost Richards (1833–1905). *Trees Along the Stream in Fall.* 1861. Oil on canvas, 12⅝ × 20. Signed: Wm. T. Richards, 1861.

[35] Samuel Colman, Jr. (1832–1920). *Storm King on the Hudson.* 1866. Oil on canvas, 31¾ × 59¼. Signed: Colman '66.

[36] Winslow Homer (1836–1910). *High Cliff, Coast of Maine.* 1894. Oil on canvas, 30 × 38. Signed: Homer 1894.

[37] John Henry Twachtman (1853–1902). *The Brook, Green-*

wich, Connecticut. 1890–1900. Oil on canvas, 24¾ × 34⅜.
Signed: J. H. Twachtman.

[38] Theodore Robinson (1852–1896). *Old Church at Giverny*.
1891. Oil on canvas, 18 × 22. Signed: Th. Robinson, 1891.

[39] Childe Hassam (1859–1935). *The South Ledges, Appledore*
(*Sunny Blue Sea*). 1913. Oil on canvas, 34 × 35½. Signed:
Childe Hassam 1913.

[40] William Sidney Mount (1807–1868). *Saul and the Witch
of Endor*. 1828. Oil on canvas, 35⅞ × 48. Signed: W. S. Mount
1828.

[41] Detail from William Sidney Mount's *Saul and the Witch
of Endor*. 1828.

[42] Benjamin West (1738–1820). *Helen Brought to Paris*. 1776.
Oil on canvas, 56¼ × 75¼. Signed: B. West 1776.

[43] Benjamin West (1738–1820). *The Death of Wolfe*. 1771.
Oil on canvas, 59½ × 84. Signed: B. West PINXIT./1770.
National Gallery of Canada, Ottawa; gift of the Duke of
Westminster, 1918.

[44] Detail from an engraving after Charles LeBrun (1619–1690).
The Death of Meleager. 1658. $16\frac{5}{16} \times 21\frac{17}{32}$. The Metropolitan
Museum of Art, New York; Elisha Whittelsey Fund.

[45] Anthony van Dyck (1599–1641). *The Lamentation*. 1634.
Oil on wood, 109 × 149 cm. Alte Pinakothek, Munich.

[46] John Trumbull (1756–1843). *Battle of Bunker's Hill*. 1786.
Oil on canvas, 24 × 34. Yale University Art Gallery, New Haven,
Connecticut.

[47] Costume plate from *Zeitung für elegante Welt*, 1843,
in Max von Boehn, *Modespiegel* (Braunschweig, 1919), p. 91.

[48] Emanuel Leutze (1816–1868). *Washington Crossing the
Delaware*. 1851. Oil on canvas, $140\frac{1}{16} \times 256\frac{1}{16}$. The Metro-
politan Museum of Art, New York; gift of John Stewart Kennedy.

[49] William Sidney Mount (1807–1868). *The Painter's
Triumph*. 1838. Oil on canvas, 19½ × 23½. Signed: Wm. S.

Mount. Pennsylvania Academy of the Fine Arts, Philadelphia, Pennsylvania.

[50] George C. Lambdin (1830–1896). *Girls and Flowers*. 1855. Oil on canvas, 22 × 18.

[51] Frank B. Mayer (1827–1899). *Independence* (Squire Jack Porter). 1858. Oil on paperboard, 12 × 16. Signed: F. B. Mayer, 1858.

[52] John Rogers (1829–1904). *The Favored Scholar*. 1873. Plaster, 24 × 17 × 13. Signed: John Rogers, New York.

[53-56] John Rogers (1829–1904). *Checkers Up at the Farm*. 1875. Plaster, painted; 19 × 18 × 14. Signed: John Rogers, New York.

[57] Alvan Fisher (1792–1863). *Niagara Falls*. 1820. Oil on canvas, 34¼ × 48⅛. Signed: A. Fisher pixt. 1820.

[58] George Inness (1825–1894). *Niagara*. 1889. Oil on canvas, 30 × 45. Signed: G. Inness, 1889.

[59] George Inness (1825–1894). *The Lackawanna Valley*. 1855. Oil on canvas, 33⅞ × 50¼. National Gallery of Art, Washington, D.C.; gift of Mrs. Huttleston Rogers.

[60] George Inness (1825–1894). *September Afternoon*. 1887. Oil on canvas, 36¾ × 28¾. Signed: G. Inness 1887.

[61] Ralph Albert Blakelock (1847–1919). *At Nature's Mirror*. Undated. Oil on canvas, 16⅛ × 24. Signed: R. A. Blakelock.

[62] Ralph Albert Blakelock (1847–1919). *Moonlight, Indian Encampment*. Ca. 1885–1889. Oil on canvas, 26⅝ × 33⅞. Signed: R. Blakelock.

[63] James Abbott McNeill Whistler (1834–1903). *Valparaiso Harbor*. Undated. Oil on canvas, 30¼ × 20.

[64] Hiroshige. "The Japan Embankment in the Yosiwara District," from *One Hundred Views of Famous Places in Edo*. Wood-block print. Second half of the nineteenth century. Freer Gallery of Art, Study Collection.

[65] John La Farge (1835–1910). *Greek Love Token*. 1866. Oil

on canvas, 24 × 13. Signed: John La Farge 1866.

[66] John La Farge (1835–1910). *The Golden Age*. 1870. Oil on canvas, 34½ × 16½. Signed: LF 1870.

[67] Wyatt Eaton (1849–1896). *Ariadne*. 1888. Oil on canvas, 14 × 18½. Signed: Wyatt Eaton, 1888.

[68] John Vanderlyn. *Ariadne*. 1812. Engraving by Asher B. Durand, 1835. 14$\frac{3}{16}$ × 17¾.

[69] Thomas W. Dewing (1851–1938). *Summer*. Ca. 1890. Oil on canvas, 42 × 54½. Signed: T. W. Dewing.

[70] Thomas W. Dewing (1851–1938). *The Spinet*. 1902. Oil on wood, 15½ × 20. Signed: T. W. Dewing.

[71] Abbott H. Thayer (1849–1921). *Virgin Enthroned*. 1891. Oil on canvas, 70¾ × 51. Signed: Abbott H. Thayer.

[72] Detail of drapery from Elihu Vedder (1836–1923). *The Cup of Death*. 1885 and 1911. Oil on canvas, 44¾ × 22½. Signed: Elihu Vedder.

[73] Elihu Vedder (1836–1923). *The Cup of Death*. 1885 and 1911.

[74] Louis C. Tiffany (1848–1933). Hand mirror in the form of a peacock. Ca. 1900. Silver, with enamel and sapphires, 10¼ × 4¾. Museum of Modern Art, New York; gift of Joseph H. Heil.

[75] Albert Pinkham Ryder (1847–1917). *Jonah*. Ca. 1885. Oil on canvas, 26⅞ × 33¾.

[76] Albert Pinkham Ryder (1847–1917). *Moonlight*. 1880–1885. Oil on wood, 15⅞ × 17⅞.

[77] Joseph Albers (1888–). *Homage to the Square, Insert*. 1959. Oil on canvas, 48 × 48.

[78] Adolph Gottlieb (1903–1974). *Three Discs*. 1960. Oil on canvas, 72 × 90.

[79] Benjamin West (1738–1820). *Helen Brought to Paris*. 1776. Oil on canvas, 56¼ × 75¼. Signed: West 1776.

[80] Joseph Albers (1888–). *Homage to the Square, Insert.* 1959. Oil on canvas, 48 × 48.

[81] Adolph Gottlieb (1903–1974). *Three Discs.* 1960. Oil on canvas, 72 × 90.

[82] Isamu Noguchi (1904–). *Grey Sun.* 1967. Arni marble, 41 × 40½ × 18.

[83] Isamu Noguchi (1904–). "Free Form" table. 1944. Polished glass and walnut, 15¾ × 50 × 36. Courtesy, Herman Miller, Zeeland, Michigan.

[84] Cover design of the journal *DE STIJL.* April 1918.

[85] Le Corbusier (1887–1965). Villa at Garches. 1927.

[86] Le Corbusier (1887–1965). Design for a modern city. 1922.

[87] Claude-Nicolas Ledoux (1736–1806). Perspective rendering of the city plan of Chaux. Designed ca. 1774; published 1804.

[88] Adolph Gottlieb (1903–1974). *Three Discs.* 1960. Oil on canvas, 72 × 90.

[89] Theodore Roszak (1907–). *Construction in White.* 1937. Wood, masonite, and plastic, 80½ × 80½ × 12.

[90] Seymour Lipton (1903–). *The Defender.* 1962. Nickel silver on Monel, 81 inches high. Lent by Marlborough–Gerson Gallery, New York.

[91] Willem de Kooning (1904–). *Woman VIII.* 1961. Oil on paper, 28½ × 22. Signed: de Kooning.

[92] Detail from Willem de Kooning's *Woman VIII.* 1961.

[93] Plate 5 from Hermann Rorschach (1884–1922). *Psychodiagnostik* (Bern and Leipzig, 1921).

[94] Helen Frankenthaler (1928–). *Small's Paradise.* 1964. Acrylic on canvas, 100 × 93.